SUCCESS IN ART

DRAWING
HANDS & FEET

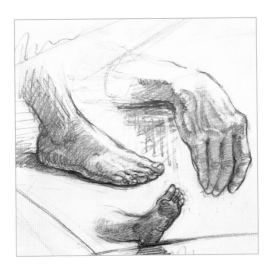

KEN GOLDMAN

D1300690

Brimming with creative inspiration, how-to projects, and useful information to enrich your everyday life, Quarto Knows is a favorite destination for those pursuing their interests and passions. Visit our site and dig deeper with our books into your area of interest: Quarto Creates, Quarto Cooks, Quarto Homes, Quarto Lives, Quarto Drives, Quarto Explores, Quarto Gifts, or Quarto Kids.

First published in 2020 by Walter Foster Publishing, an imprint of The Quarto Group. 26391 Crown Valley Parkway, Suite 220, Mission Viejo, CA 92691, USA.
T (949) 380-7510 **F** (949) 380-7575 **www.QuartoKnows.com**

Walter Foster Publishing titles are also available at discount for retail, wholesale, promotional, and bulk purchase. For details, contact the Special Sales Manager by email at specialsales@quarto.com or by mail at The Quarto Group, Attn: Special Sales Manager, 100 Cummings Center, Suite 265D, Beverly, MA 01915, USA.

ISBN: 978-1-63322-856-6

Digital edition published in 2020
eISBN: 978-1-63322-857-3

Printed in China
10 9 8 7 6 5 4 3 2 1

Table of Contents

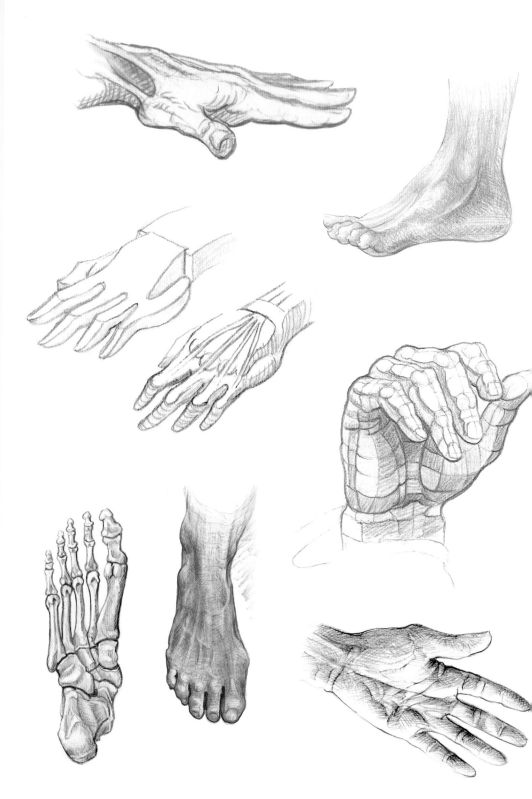

Introduction

This book is chock-full of illustrations, demonstrations, and even a color-coded section on anatomy. I've approached this challenging but fun subject from two directions: a "direct seeing approach" and a "structural approach."

The Direct Seeing Approach

In this approach, an artist learns how to see and draw shapes rather than "things." Shapes, such as hands or feet, are drawn objectively without being labeled as what they are. This removes the stigma of hands or feet being "too difficult to draw." With this shift in attitude, hands and feet suddenly become unique abstract shapes with very definite values. As these puzzlelike shapes are carefully put together, they evolve naturally into an accurate hand or foot drawing.

The Structural Approach

In this way of working, artists learn to simplify the complex anatomical shapes of hands and feet into basic simplified geometric forms, such as blocks, spheres, cylinders, and cones. Basic forms are much easier to draw than palms, knuckles, and fingers. Beginning this way creates a firm foundation on which to continue building toward more complex anatomical details. The illustrations in this book will take you through a step-by-step process of learning to see shapes, identifying their light and dark values, and assembling them into recognizable images.

Section I of this book shows how easy it is to set up a simple studio almost anywhere. The only tools I recommend are the same ones used for all of the drawings in this book.

Section II covers basic hand and foot anatomy (for artists, not doctors) with color-coding to help you remember which bones are which.

Section III describes the different techniques of seeing and transferring what is seen onto paper, understanding the picture plane, knowing when and how to use positive and negative shapes, and the importance of values and perspective in relation to hands and feet.

Section IV helps to put what you've learned into action: drawing from life, working from photographs, and building detailed step-by-step hand and foot drawings in graphite, charcoal, and Conté pencil.

I am extremely grateful to my artist wife, Stephanie Goldman, who was not only my best hand and foot model but was always there to proof every drawing and to keep my writing as clear as possible.

Jump in and make this book look ragged through overuse! I wish you much success in your drawing adventure.

— Ken Goldman

Tools & Materials

One of the best parts of drawing on a pad is its simplicity. This is especially useful for life-drawing groups where only a drawing board, pencils, charcoal, and drawing pad are necessary. Even at home, when many other tools and materials are available, I favor the following supplies for their compact effectiveness and mobility.

Drawing Tools

Mechanical Graphite Pencils

A 2.0mm 4B and .05mm 2B pencil are essential. The 2.0mm works great for most of the drawing, while the smaller .05mm is perfect for final crosshatching and details. Compared to wooden pencils, mechanical pencils are much easier to sharpen with sandpaper and work better for shading large areas with their long-tapered leads.

Many artists also use harder leads such as HB, 2H, or 4H to attain their lightest values. But if you are careful with hand pressure, as your drawing progresses, a 4B not only yields the lightest values but, with increasing pressure, will also deliver the rich middle and darker values.

For ease of quick erasing, try wrapping a small piece of kneaded eraser around the end of the pencil to erase with its side.

.05mm 2B

2.0mm 4B

"TECH" DA ITALY

Conté Pencils

My favorite Conté pencils are the Conté #630 Blanc (white for toned paper), Sanguine #610, Sepia #617, and Black B #1710 (mainly for line accents and toning).

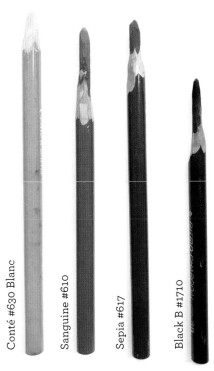

Conté #630 Blanc

Sanguine #610

Sepia #617

Black B #1710

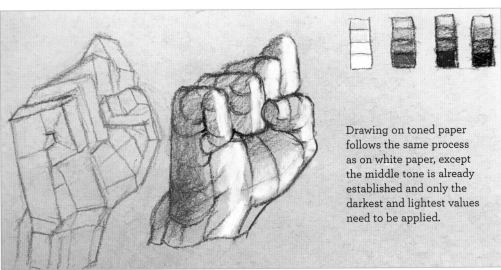

Drawing on toned paper follows the same process as on white paper, except the middle tone is already established and only the darkest and lightest values need to be applied.

Whether your paper is white or toned, sanguine is the best pencil to start with because its textural dryness makes it easy to stay light at the beginning. As the drawing progresses and sanguine starts looking too red, sepia is the next step for further darkening. Finally, black is mainly used for final accents and overall toning. Conté white is not very bright, so it should only be used for general lightening. To indicate highlights and brighter areas, use a softer white pastel sparingly.

Charcoal Pencils

Charcoal pencil lead is a combination of graphite and clay, which provides a unique gliding characteristic. It is available in grades ranging from H to 3B. Soft 3B pencils produce intense lines and rich, dark tones, but they are also difficult to sharpen without breaking. I recommend a B or 2B if you are new to sharpening. Conté, General's®, Prang®, and Ritmo® all make excellent charcoal pencils of varying hardness.

Conté #1710 B

Vine & Willow Charcoal

Although both are often called vine, there is a difference between vine and willow charcoal. Vine charcoal (from charred grapevines) is dark gray, while willow is black. Vine and willow are excellent for large drawings but do not work as well for small drawings or final crisp details. I recommend starting with soft vine charcoal for the lay-in and using a charcoal pencil for final details.

Green NuPastel Chalk

In addition to being a great drawing tool on its own, vine charcoal also acts as a subtle gray toner for various colored pastels such as NuPastel 308-P. Try first massing-in with the NuPastel chalk, and then begin adding vine charcoal shading and linework.

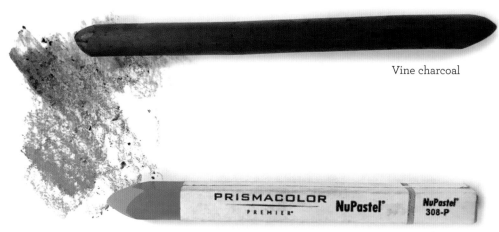

Vine charcoal

Green NuPastel 308-P

Blending Tools

Large and small blending stumps called tortillons are used to soften or blend large or small areas. Blending to show value transition is a good thing, but sometimes overblending makes a drawing look too photographic. This may be your goal, but if not, the introduction of crosshatched and form-following strokes over the blended areas will help bring back the more spontaneous look of a drawing.

Tortillons

Erasers

Erasers are not only for correcting mistakes; they are just as effective for creating interesting drawing strokes in toned areas. Kneaded erasers can be molded into any shape, such as a point for picking out specific lights, or can be used bluntly to lighten up an area with tamping. When a kneaded eraser gets dirty, simply knead it until it is clean again.

Plastic erasers are primarily used to add a variety of lifted strokes in toned areas and, in the case of the pen eraser, for erasing in small areas. When the plastic gets dirty and no longer erases, simply cut off the dirty area with a razor blade. Unlike kneaded erasers, plastic erasers leave erasing crumbs, so keep a small, soft brush in your tool kit to gently remove them.

Kneaded erasers

Plastic erasers

9

Sharpening Tools

All of these razor blades work equally well for sharpening. The orange touch-blade is my go-to blade for travel. The X-Acto® blade and utility knife are good sharpeners for studio use.

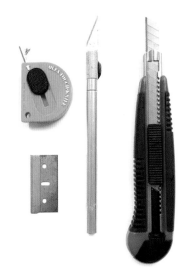

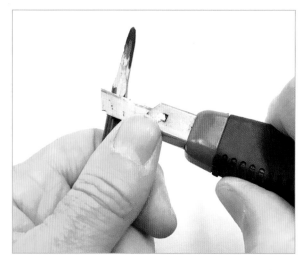

When whittling the wood away, always be sure to push the back of the blade with your thumb. This method gives the greatest control and the least likelihood of a broken lead or sliced finger.

Sandpaper

Use a commercial sandpaper block from the art store or just tear off a piece of regular sandpaper. A very fine 150 grit sandpaper block works well to slowly and carefully shape lead, but often clogs after several rounds. A quicker alternative is to use a piece of 50 to 90 grit sandpaper, which sharpens pencils quickly and does not get clogged up.

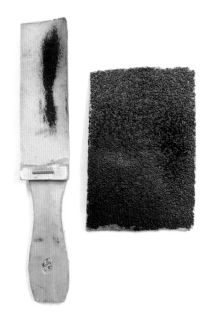

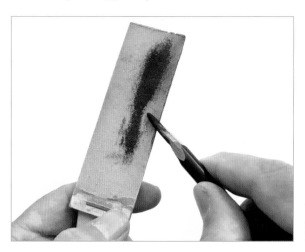

When sharpening, hold the pencil as flat as possible and slowly rotate it to keep the tapered lead consistent.

Drawing Surfaces

White Paper

Whether to use white or toned paper depends on your experience level. White paper is a good place to start because it is simple and straightforward. For the sake of economy, a pad of 11" x 14" Strathmore 300 works well for small drawings. As you become more confident in your pencil skills, try out the slightly more expensive smooth Bristol series 400, which works really well for graphite.

Toned Paper

Toned paper allows for the addition of white, which creates a dramatic third dimension. Conté pencils, graphite, and charcoal all work great on toned paper. Strathmore makes both tan and gray pads, as well as many other colors. Canson makes a wide array of toned colors too, but if you choose to use Canson, turn the paper over and use the smoother backside.

If the paper pad does not come spiral-bound (which makes it easier to flip pages), take it to your local office-supply store, where they can quickly convert it for you. Depending on the size of your work station, pads should be anywhere from 9" x 12" to 18" x 24".

This 24" x 18" newsprint pad is clipped to a homemade 3/16" foam-core drawing board with taped edges and a string handle. My regular pad is clipped to another homemade board in the same way. When you go to a sketch group, take two pads: newsprint for practice and good drawing paper for longer poses.

Newsprint

Newsprint is a cheap paper-pulp, non-archival alternative to good-quality acid-free, cotton content drawing paper. Newsprint is primarily used for practicing 2- to 10-minute gesture drawings in a sketch group. Longer poses should be drawn on higher-quality paper.

Because high-quality paper does not take charcoal as well as newsprint, artists sometimes get addicted to newsprint and don't want to move on to better papers. But when work is intended for sale, newsprint is completely useless, as it yellows and deteriorates quickly.

Assorted Papers

If you are interested in experimenting with other types of papers, buy them as individual sheets and have an office-supply store cut and spiral-bind them into a pad with cardboard backing. In general, a top-bound vertical format is preferable to a side-bound horizontal format, as it can fold back over the top of your board and save space when you are in a sketch group. Below are some samples of quick gesture sketches on newsprint and the way a board and paper can be propped up on your lap during a sketch group.

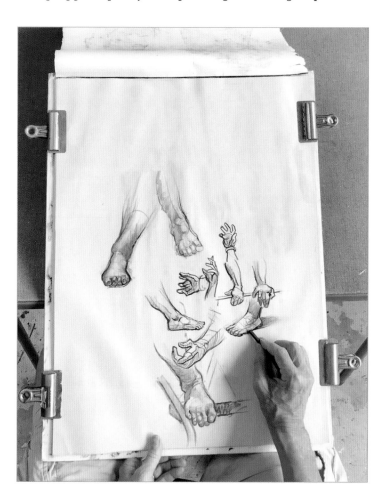

Sketch Group

There is no better way to practice hands and feet than to draw them from a live model at a sketch group and then compare and study the anatomy more closely at home from books. You can either stand with an easel or sit at a table; but remember, seated artists get to sit in the front where it is easier to see details.

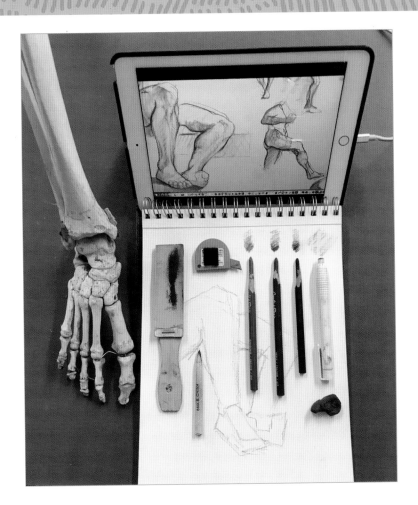

Work Space

A work space for drawing can be as simple as a card table with a good light source. If you are right-handed, the light should come from your left, so your hand does not cast a shadow on your work. If you are left-handed, the light should come from the right. Drawing tools should be limited to only those you are using and be kept close to whichever hand you use for drawing.

Place a tablet or smartphone in front of your drawing pad. Devices are often better to work from than books because they can enlarge images quickly, and if you have a question about anatomy, you can quickly find the answers on the internet. If you see something in a book that you want to copy, take a picture with your device so you can enlarge it, if necessary, and take it with you to study wherever you go.

If possible, buy a skeleton to draw from. Using a physical skeleton in conjunction with a good anatomy book is a perfect way to further understand the drawings you make from an actual model in a sketch group. I own a real-bone skeleton, but plastic skeletons work just as well and are much less expensive.

Strokes & Shading

The purpose of representational drawing is to make flat shapes appear three-dimensional. The varied lines, values, and textures you apply are the keys that unlock this illusion of depth. Although there are many types of strokes available to an artist, I have narrowed them down to the strokes you are most likely to use when drawing hands and feet, as well as why, how, and where these strokes are most often used in my own drawings.

Graphite Strokes

Graphite pencil strokes can be softened to a point of photographic realism or left unblended for a livelier look. I tend to leave my strokes mostly unblended, but the underlying principles behind achieving any degree of finish are still the same.

The following examples were all drawn from life in a series of 20-minute poses. Beyond the specific areas pointed out, look at other parts of the drawing to see where similar strokes might have been applied.

A. Curved hatching over blended strokes show the foot's edge.
B. Short hatching strokes indicate the wrist's blocky shadow edge.
C. Thin light lines show details of the unstretched knuckle's skin.

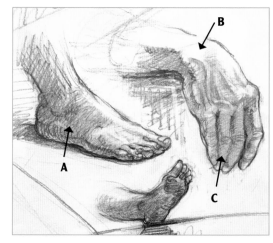

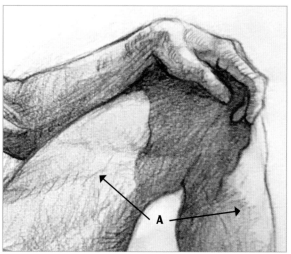

A. A kneaded eraser lightens the values, so arm, hand, and knee become the focal point.

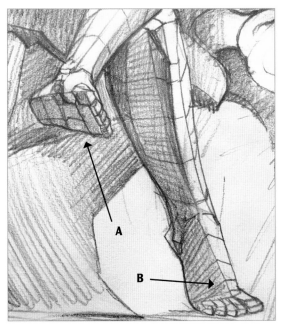

A. Bottom plane of the foot is blended with a tortillon to indicate flat shading.
B. Straight, hatched lines indicate directional plane changes on the model's forefoot.

A. Form-following cross-contour lines define how to shade the muscle shapes of the forearm. A dark outer contour line unifies and defines the outer shape of the hand.
B. Notice how the fingers in shadow are softly blended and subtly outlined.

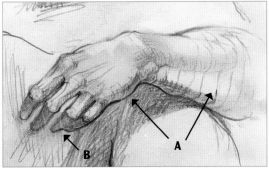

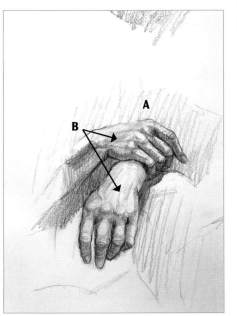

A. Bringing focus to only one area on a page is called a vignette. In this case, soft, simple strokes behind much darker, complex strokes on the hands create a definite focal point.
B. Top of hands are blended with a tortillon and veins are lifted out with a plastic pen eraser.

Conté Strokes

Conté pencils on white paper have a warmer look than graphite. Although they are definitely a drawing tool, sometimes they feel more like paints.

The following examples were all drawn from life in 20- to 40-minute poses. Notice how much of the drawing process involves vigorous linework, blended tones, and eraser marks.

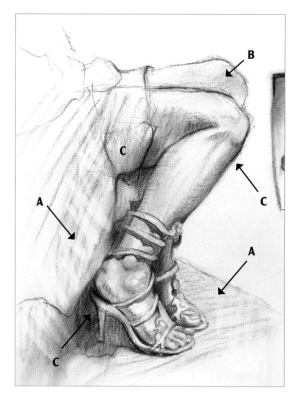

A. These areas were blended with my finger and lightly erased to add directional interest.
B. The far knee, overlapped by a dark line, is softened and kept less detailed so it recedes.
C. The dark areas are a mixture of sanguine, sepia, and black charcoal pencil. These accents help to engage the viewer's eye. Notice how the dark area under her heel brings out the reflected light. The shadow core is indicated by short sepia strokes.

A. The line on the heel is kept light so it recedes behind the much darker toes and ball of the foot.
B. Light scribbly charcoal lines give a sense of the convex fat pad, while also following the direction of the underlying metatarsal bones.
C. This mid-tone area is blended with a tortillon to bring out the light on the foot's instep.
D. The darkest accents complete the value scale, adding life to the drawing.

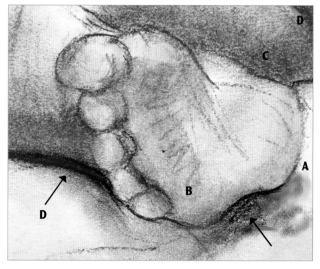

A. Eraser strokes parallel to the arm add interest.

B. The cast shadow originating from the sleeve and fingers lightens gradually as it progresses away from the hand. Sepia and sanguine are blended with the tortillon.

C. Although the thumb is in shadow, its dark side is still lighter than the cast shadow. Light areas along the entire thumb were lifted out with a plastic eraser, while knuckle wrinkles were drawn back in with sepia.

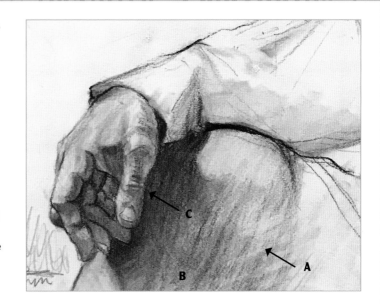

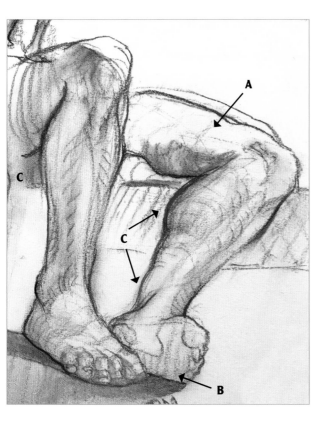

A. The form-following cross-contour lines indicate that the cylindrical-shaped upper and lower leg are slightly foreshortened.

B. While the right foot is nearly finished, the bottom of the left foot is only blocked in, but accurately. Viewers often find unfinished drawings more fulfilling because they get to see a part of the artistic process.

C. Vigorous, varied linework on both legs adds excitement to the entire drawing.

Charcoal Strokes

A well-sharpened charcoal pencil is nearly unrivaled when it comes to laying down expressive linework and multi-valued black and white tones.

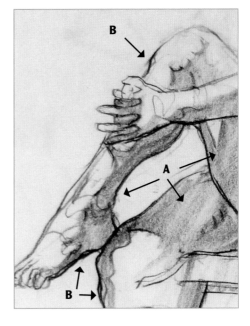

A. The flat shadow shapes on this 10-minute sketch were applied with the tapered edge of the lead.
B. After tones are applied, final linework is added by pulling or pushing the sharp tapered point in the direction of the outer contours with varied pressure. Notice the dark accents on the knee, wrist, foot, and cast shadow.

These five-minute gestures show the importance of quickly finding large tonal shapes, correct angles, and varied contour lines.

A. The various plane changes and details on these feet are indicated through subtle tone changes and linework.

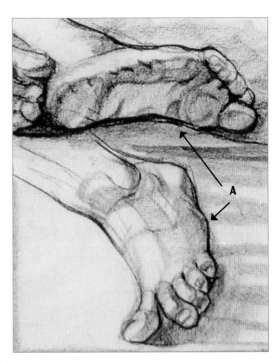

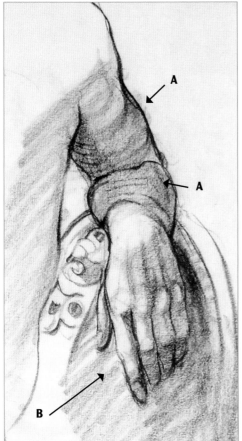

A. Foreshortening is indicated by following the shape of a cylinder with blurred and crisp cross-contour lines.
B. The top of the hand and the three shadowed fingers were toned with the side of the long, tapered lead.

Vine Charcoal Strokes

Vine charcoal works well for large-format drawings and is a perfect drawing tool for beginners, yet it is often also favored by professionals for its versatility.

This 5-minute gesture shows how dark willow accents enliven the grayer vine and green mix.

A. Start with a vine charcoal layout.

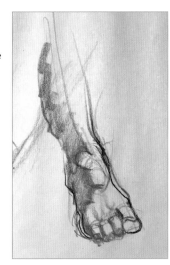

B. Mass in the shadow shapes with the green NuPastel.

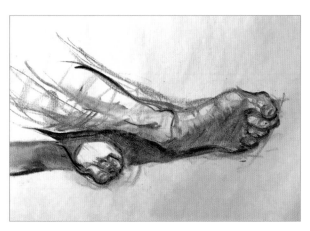

C. This foot study shows how well the green and vine blend together with a tortillon.

This is an example of an entirely hatched and crosshatched drawing. Crosshatching with vine charcoal requires continual sharpening on sandpaper. A plastic eraser with a razor-sharpened edge can also be used to make hatch marks.

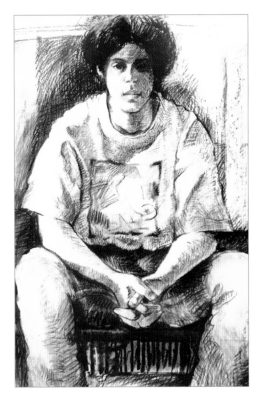

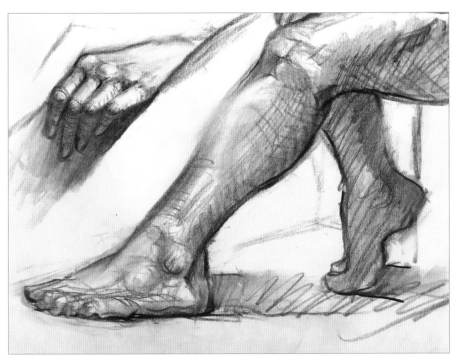

This 20-minute drawing shows how vine and NuPastel tones in conjunction with various vine charcoal strokes create a lively finish. Form-following strokes on the hand, legs, and front foot create a sense of volume. Diagonal blended strokes push the far leg back.

Anatomy of Hands & Feet

Because most major hand and foot muscles originate in the forearms and lower legs, we must begin with the forearms and lower legs to fully understand the anatomy of the hands and feet.

"First we draw what we see; then we draw what we know; finally, we see what we know..."

—Robert Beverly Hale

Anatomy of the Forearm

Muscles of the forearm whose tendons insert into the hand are called extrinsic muscles. The muscles of the hand itself are called intrinsic muscles. The extrinsic forearm muscles are divided into three main groups: flexors, extensors, and ridge muscles.

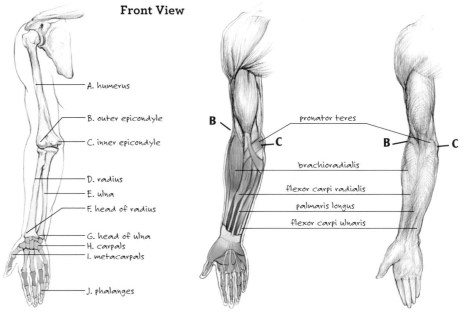

Front View

A. humerus
B. outer epicondyle
C. inner epicondyle
D. radius
E. ulna
F. head of radius
G. head of ulna
H. carpals
I. metacarpals
J. phalanges

B
C
pronator teres
brachioradialis
flexor carpi radialis
palmaris longus
flexor carpi ulnaris
B
C

Bones The underlying skeletal structure determines much of the overall shape of the arm. Several elements of this substructure, such as the *inner epicondyle* (C), act as visual landmarks that are identifiable even under layers of muscle and skin.

Flexors Located on the bottom-side of the arm, this group originates on the *inner (medial) epicondyle* of the *humerus* (C) and inserts into the palm side of the hand. *Flexor carpi radialis*, *flexor carpi ulnaris*, and *palmaris longus* bend the palm and clench the fingers. Flexor tendons are easily seen at the wrist, especially the thin *palmaris longus* tendon nearest the center.

Selected Anatomical Definitions Pertaining to Positions, Flesh & Bones

■ POSITIONS
Midline Divides body into right and left sides

Medial Nearer to midline
Lateral Farther from midline

Anterior Front
Posterior Rear

Proximal Nearer to root of limb
Distal Farther from root of limb

Palmar Refers to palm side of hand
Plantar Refers to sole of foot
Dorsal Refers to back of hand and top of foot

Supine Forearm and hand, turned palm-side upward
Prone Forearm and hand, turned palm-side downward
Inverted Foot turned inward at ankle joint
Everted Foot turned outward at ankle joint

■ FLESH
Muscle Contractile organ capable of producing movement
Muscle belly Fleshy part of a muscle

Flexor Bends
Extensor Straightens
Abductor Draws away from midline
Adductor Draws towards midline
Supinator Turns palm of hand upward
Pronator Turns palm of hand downward

Origin Relatively fixed point of a muscle attachment
Insertion Relatively movable point of a muscle attachment

Tendon Fibrous tissue securing a muscle to its attachment
Ligament Fibrous tissue binding bones together or holding tendons/muscles in place

Aponeurosis Expanded tendon for attachment of a flat muscle
Fascia Fibrous envelopment of muscular structures
Sheath Protective covering

■ BONES
Condyle Polished articular surface (usually a knob)
Epicondyle Elevation near a condyle
Protuberance A protrusion or bump (can be felt under finger)
Head Enlarged knob of a long bone
Neck Constriction of a bone near its head
Shaft Longest part of a bone

Back View

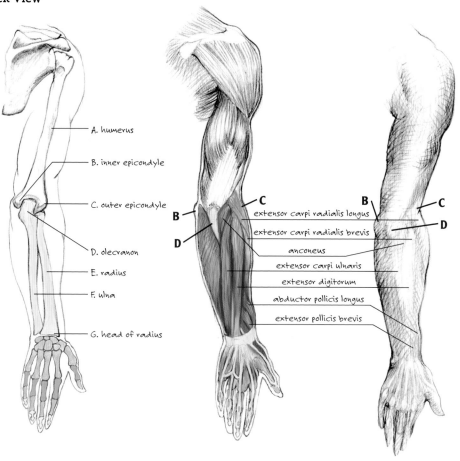

A. humerus

B. inner epicondyle

C. outer epicondyle

D. olecranon

E. radius

F. ulna

G. head of radius

C
extensor carpi radialis longus
B
extensor carpi radialis brevis
D
anconeus
extensor carpi ulnaris
extensor digitorum
abductor pollicis longus
extensor pollicis brevis

B

C
D

Bones Much of the overall shape of the arm in the back view is determined by the underlying skeletal structure, just as with the front view. The *inner* and *outer epicondyle*, (B) and (C), are again identifiable, even under layers of muscle. And from this view, the *olecranon*, or elbow (D), is also evident.

Extensors These muscles straighten the wrist and open the fingers. The main muscles in this group are *extensor carpi radialis brevis, extensor carpi ulnaris,* and *extensor digitorum*. Located on the top side of the forearm, these muscles originate on the *outer (lateral) epicondyle* of the *humerus* (C) and travel over the top of the forearm to insert onto the upper (dorsal) side of the hand. The two extensor muscles of the thumb will be covered in the next section on hand anatomy.

Side View, Clenched Fist

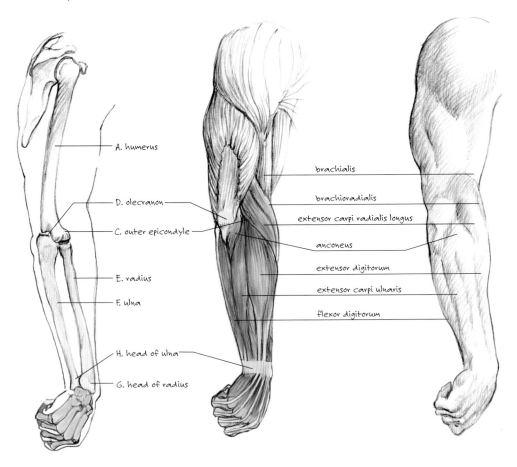

A. humerus

D. olecranon

C. outer epicondyle

E. radius

F. ulna

H. head of ulna

G. head of radius

brachialis

brachioradialis

extensor carpi radialis longus

anconeus

extensor digitorum

extensor carpi ulnaris

flexor digitorum

Bones Here the arm is not viewed in full profile; rather it is seen from an angle that is a combination of a side view with a touch of back view. Because of the angle, the bony landmarks most apparent under the muscles are the *olecranon* (D), *outer epicondyle* (C), and *head of ulna* (H).

Muscles The side view provides a good angle for observing the extensors and flexors of the upper and lower arm. The *brachioradialis*, located where the upper and lower arms meet, is particularly important. It originates on the lateral side of the *humerus* (A), above the *outer epicondyle* (C), and then attaches to the lateral side of the wrist above the *head of radius* (G).

Ridge muscles (supinators)

Originating at the base of the upper arm (*humerus*), the two ridge muscles, *brachioradialis* and *extensor carpi radialis longus*, rotate the hand outward into a position of supination (palm up).

Origin ◯

Flexors **F**

Extensors **E**

Ridge **R**

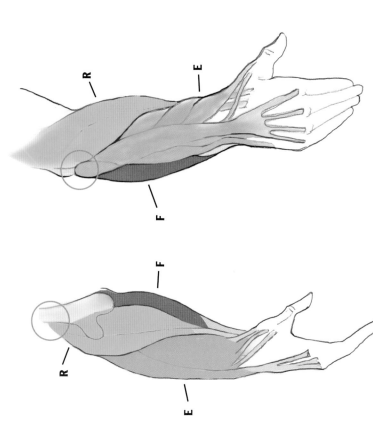

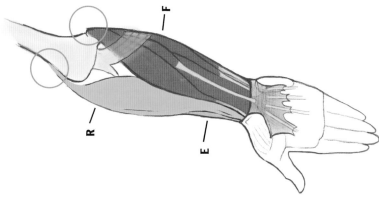

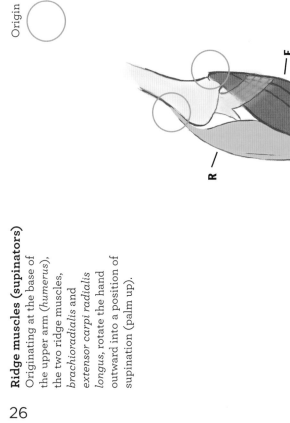

Anatomy of the Wrist & Hand

I'd like to start with a disclaimer. The skeleton I'm using for the photos and drawings in this book is a real skeleton. The bones are 100-percent accurate, but because they are put together with bolts, nuts, and wires, their positioning may sometimes be a little off. However, once this small flaw is taken into consideration (and corrected in your final drawings), it is still a great representation of how well the joints work together.

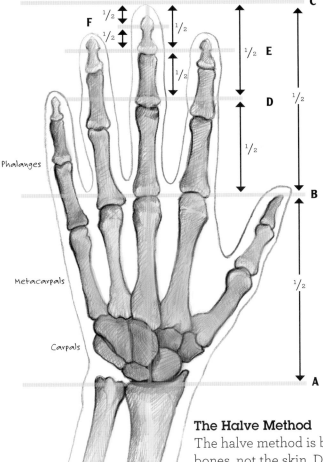

Phalanges

Metacarpals

Carpals

Left hand (dorsal view)
The hand's surface form is based mostly on its skeletal shape. The skeleton of the hand consists of *carpals*, *metacarpals*, and *phalanges* (a.k.a. the wrist, palm, and fingers). When looking straight down at the hand, a simple way to find correct proportions is to use "the halve method."

The Halve Method

The halve method is based on the length of the bones, not the skin. Divide the distance between the end of the carpals (A) and the tip of the middle finger (C) to find the middle of the hand (B), which is also where the heads of the metacarpals (knuckles) are located.

To find the length of the three finger joints (B-C), divide the distance between B and C to find D. Divide the distance between D and C to find E, the top two joints, and again to find F, the fingernail. Try using this measuring technique on your own hand.

Palmar Side
Fingers look shorter

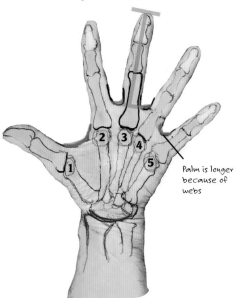

Dorsal Side
Fingers look longer

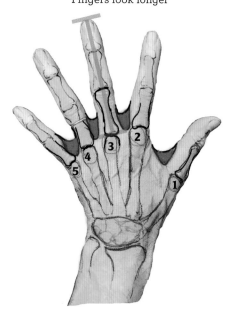

Palm is longer because of webs

Webbing of the palm (palmar and dorsal views) Notice how your palm, with its webbing, looks longer than the top of your hand. Also notice how your fingers look longer from the dorsal view than they do from the palmar view. This is because the webbing of the palm extends beyond the knuckles (metacarpal heads), nearly halfway to the first joints of the phalanges.

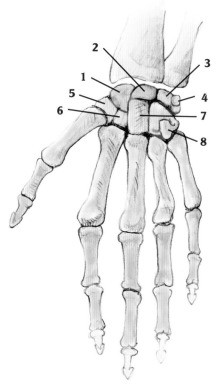

Bones The wrist contains eight irregular carpal bones, arranged in two rows of four bones each. Proximal: *scaphoid* (1), *lunate* (2), *triquetral* (3), *pisiform* (4); Distal: *trapezium* (5), *trapezoid* (6), *capitate* (7), *hamate* (8).

Here is a good way to remember the names of the eight carpal bones:

Sally **L**eft **T**he **P**arty
To **T**ake **C**athy **H**ome

Right Hand (palmar view)

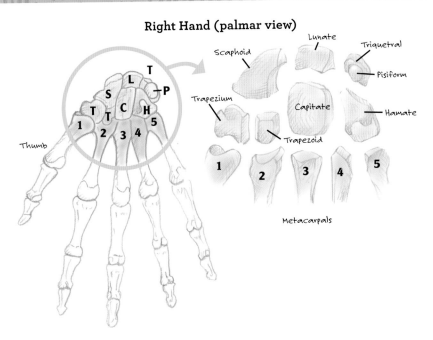

Scaphoid
Lunate
Triquetral
Pisiform
Trapezium
Capitate
Hamate
Trapezoid
Thumb

T
S
L
T P
T C H
T 5
1 2 3 4

1 2 3 4 5

Metacarpals

Right hand (palmar view) Carpal bones have essentially flat surfaces. Where they fit together, they form gliding joints, which limit their movements. Numerous small ligaments bind each carpal to each other and to the metacarpals.

Even though individual carpal bones do not show through the skin, it's still good to know their names for anatomical understanding. However, when it comes to actually drawing the carpal bones, it's better to simplify them as a half circle, much like the semirounded shape of a half-moon.

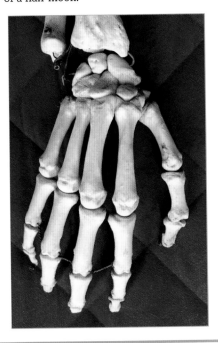

Metacarpals There are five metacarpal bones, beginning with the thumb. Each bone consists of a boxlike proximal base, a shaft, and a rounded distal head. All metacarpals, except the thumb, radiate from an imaginary center point on the distal end of the radius.

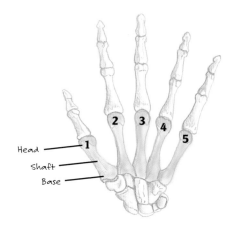

Head
Shaft
Base

Left Hand (palmar view)

These diagrams show how metacarpals 2–5 radiate from an imaginary center point on the distal end of the radius, as well as the placement of metacarpal heads on the palm.

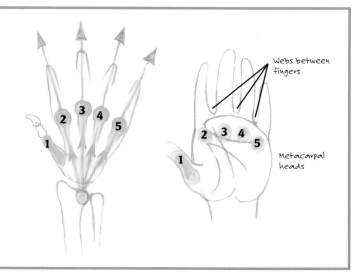

Webs between fingers

Metacarpal heads

Phalanges All fingers, except the thumb, have three phalanges. The thumb only has two. The individual bones of each finger are called the *proximal, middle,* and *distal phalanges.* In Greek, *phalanx* means "a line of soldiers."

Fingers 1–5 are called:
thumb (1)
index (2)
middle (3)
ring (4)
little (5).

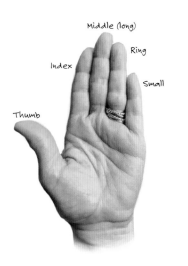

Thumb
Index
Middle (long)
Ring
Small

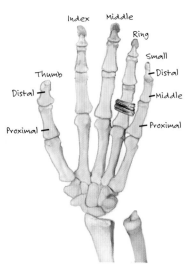

Index
Middle
Ring
Small
Thumb
Distal
Proximal
Distal
Middle
Proximal

Muscles

There are no muscle fibers in the fingers; only tendons, bones, and fat. The muscles and short tendons of the hand (intrinsic muscles) arise only on the carpals and metacarpals.

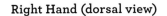

Right Hand (dorsal view)

Bones From this view of the hand, all the same bones are visible, but the carpal bones appear convex rather than concave. From this angle, the bones have more influence on the shape of the fleshed-out hand.

Muscles *Extensor carpi ulnaris* (A), *extensor digitorum* (B), *extensor carpi radialis brevis* (C), and *extensor carpi radialis longus* (D) are visible forearm tendons that extend into the hand. These four tendons and the *extensor tendons* of the thumb (E) are visible when contracted. The first *dorsal interosseous* (F) is the largest of the four dorsal interosseous muscles, and it is the only one that shows its form through the skin's surface; when the thumb is flexed, this muscle appears as a bulging teardrop shape. A wide, thick ligament called *extensor retinaculum* (G) holds the extensor tendons tightly in place.

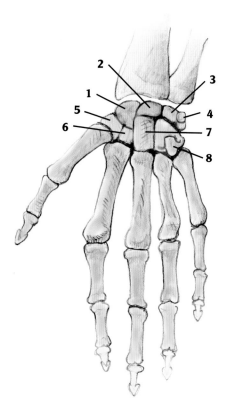

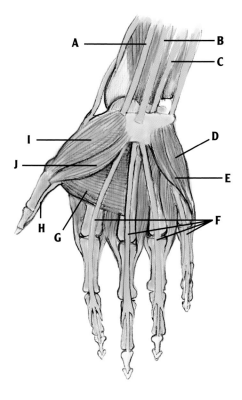

Muscles The flexor tendons of the forearm muscles, *flexor carpi radialis* (A), *palmaris longus* (B), *flexor digitorum superficialis* (C), and *flexor carpi ulnaris* (D), all extend down into the hand. The teardrop-shaped muscle masses, the *thenar eminence abductors* of the thumb (I, J) and the *hypothenar eminence abductor* (E) and *flexor* (F) of the little finger, are known as the "palmar hand muscles." The *adductor* of the thumb (G) lies under the *flexor tendons* (F). The visible creases of the palm result from the way the skin folds over the fat and muscles of the hand.

Range of Motion: Extension & Flexion

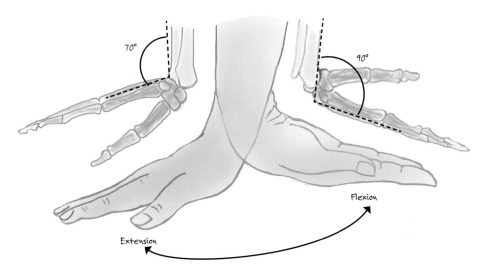

70°

90°

Flexion

Extension

Right hand (radial side view) Although hand movements are varied and expressive, they are restrained by the borders of the radial and ulnar styloid processes. Hands cannot extend too far forward or flex too far back. The design of the radial and ulnar heads help to prevent unintentional sprains and tears. Range of motion for an open hand is greater in flexion than it is in extension (90 degrees vs. 70 degrees).

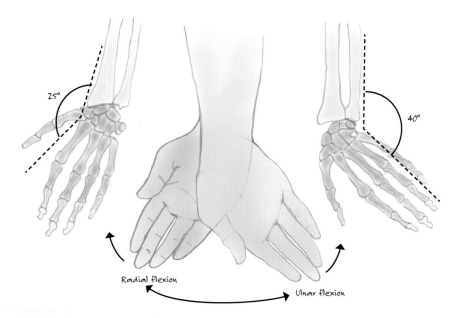

25°

40°

Radial flexion

Ulnar flexion

Right hand (palmar view) Side-to-side movement is also limited by the styloid processes of the ulna and radius. Once again, this helps to avoid wrist sprains. As this diagram shows, radial flexion is more limited than ulnar flexion because the styloid process of the radius sits lower than the head of the ulna.

Hand Landmarks & Drawing Tips

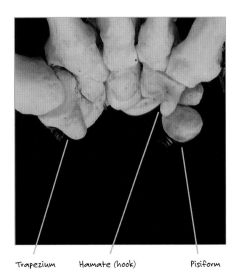
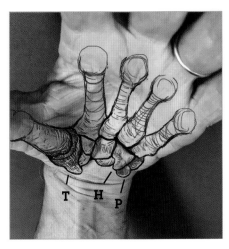

Trapezium Hamate (hook) Pisiform

Flexed hand (palmar view) Form follows function. Because the hand is designed to hold a wide variety of objects, the wrist and entire palm are concave.

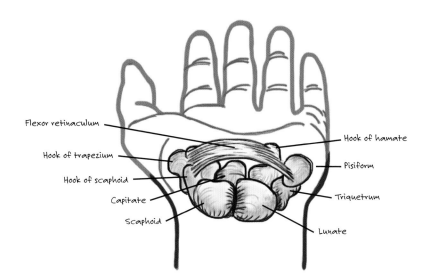

Extended hand (palmar view) Carpal protrusions of the *trapezium, hamate,* and the pealike *pisiform* bone form the carpal tunnel. The thick ligament called *flexor retinaculum* holds the flexor tendons tightly in place during flexion. When extended, as in this view, the non-contracted flexor tendons are stretched taught.

Palmar muscles The *thenar eminence* (ball of the thumb) is made up of *abductor pollicis brevis* and *flexor pollicis brevis*. It originates on the *scaphoid*, *trapezium*, and *first metacarpal*. The *hypothenar eminence* (muscle mass of the little finger) consists of *abductor digiti minimi* and *flexor digiti minimi brevis*. Look at your own hand and note how the heads of the metacarpals under the fat pads and muscle masses form creases in the palm, especially when flexing the fingers and moving the thumb.

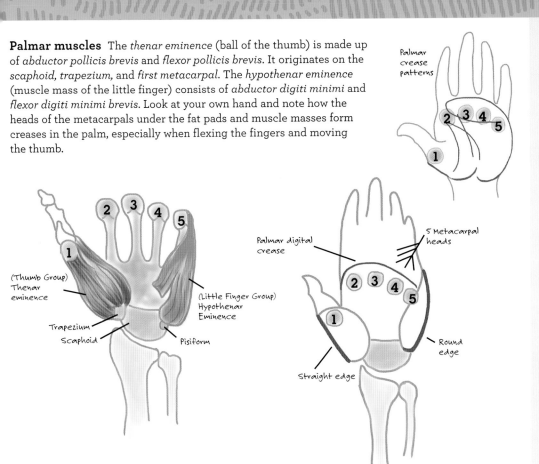

Palmar crease patterns

(Thumb Group) Thenar eminence

Trapezium

Scaphoid

Pisiform

Palmar digital crease

(Little Finger Group) Hypothenar Eminence

5 Metacarpal heads

Straight edge

Round edge

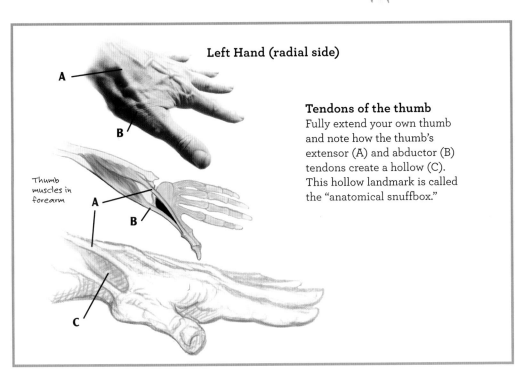

Left Hand (radial side)

Tendons of the thumb
Fully extend your own thumb and note how the thumb's extensor (A) and abductor (B) tendons create a hollow (C). This hollow landmark is called the "anatomical snuffbox."

Thumb muscles in forearm

35

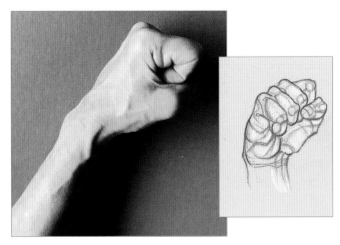

Drawing a fist The protruding knuckles are actually the distal heads of the metacarpals. The proximal phalanges (where rings are worn) adjoin the metacarpals at a 90-degree angle. The middle phalanges (where we knock on doors), adjoin the proximal phalanges at 90 degrees. Distal phalanges, the shortest of all, are tightly tucked behind the thumb and into the thenar and hypothenar eminences.

Phalanges When relaxed, fingers 2, 4, and 5 tend to curve slightly toward the straight middle finger (subtly, unlike this diagram's exaggerated curves). If fingers 2, 3, and 4 are held together, they form a continuation (width-wise) of the boxlike wrist. Hold your own hand in this tight-fingered position and notice how the thumb and little fingers act independently.

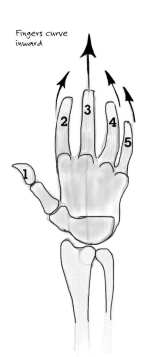

Fingers curve inward

Fingers 2, 3, 4 line up with blocklike shape of radius and ulna

Triangle

Roundin

Extensor digitorum tendons Extensor tendons of the fingers bulge at the wrist, creating a slight ramp over the carpal and metacarpal bones.

Joints

Joints are areas where bones are linked together. They have varying degrees of mobility and are classified into three basic types: immovable joints (cranial sutures), slightly movable joints (intervertebral discs), and freely movable joints (also called synovial joints).

For the purposes of this book, we are only concerned with five types of freely movable synovial joints found in the hands and feet:

Plane joints (e.g., joints of the wrist) glide face to face, limited by their retaining ligaments.

Hinge joints (e.g., joints of the fingers and thumb) can only swing back and forth. Bone movement is restricted to one plane.

Saddle joints (e.g., joint of thumb) increase the range of hinge joints by permitting 360-degree motion (but no rotation). The saddle joint gets its name because one part of the joint is concave and looks like a saddle. The other bone's end is convex and looks like a rider in a saddle.

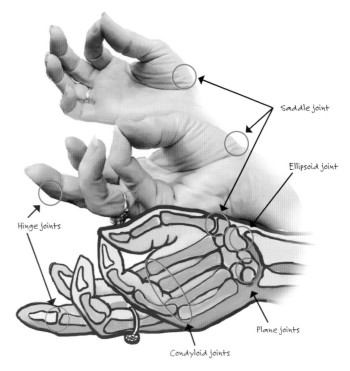

Saddle joint

Ellipsoid joint

Hinge joints

Plane joints

Condyloid joints

Condyloid joints (e.g., joints of first row of knuckles) increase the extent of the saddle joint by permitting limited circular movement.

Ellipsoid joints (e.g., oval part of wrist) are a modified ball-and-socket where the uniting surfaces are ellipsoidal rather than spherical.

The mobile thumb With its teardrop muscle and saddle joint, the thumb can move in almost any direction. While the other fingers are also mobile, their lateral movement is diminished by their medial and distal hinge joints, which can only move in one plane. This limitation is compensated for by the knuckle's condyloid joints, where circular movement is possible.

Fat Pads

Except for the thumb, each finger has three fatty finger pads, which act as protective cushions. The thumb has only one well-developed pad on its distal phalanx. The finger pads extend past the ends of all of the phalanges in order to protect the tips of the bones. The palm is cushioned by fat in three areas surrounding the central palmar aponeurosis: the *metacarpal heads*, *thenar eminence*, and *hypothenar eminence*.

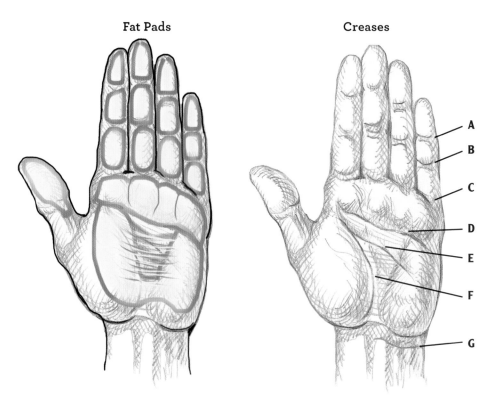

Fat Pads Creases

Palmar Creases

The way skin stretches and folds over the fat pads creates permanent creases on the fingers and palms. Creases tell the history of where the hand bends repeatedly, so most joints have corresponding creases, especially as we age.

Phalanges

A. Distal digital crease
B. Middle digital crease
C. Proximal digital crease

Palm & Wrist

D. Distal palmar crease (heartline)
E. Proximal palmar crease (headline)
F. Thenar crease (lifeline)
G. Wrist crease

Finger pads extend slightly past the end of each distal phalanx to protect the bony tips underneath fingernails. Not only do fat pads cushion and protect the finger bones, their "cushiness" also allows us to gently hold objects without dropping them.

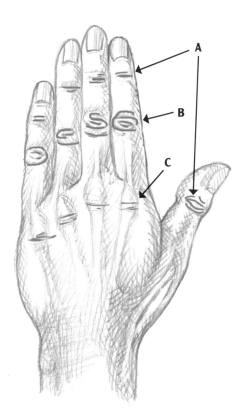

Dorsal finger wrinkles Because the bony dorsal side of the hand has no fat pads, it is not creased like the palmar side. In fact, its "wrinkles," which cover the distal and middle joints, are really just excess skin, all bunched up after years of extension and flexion.

The distal joint wrinkles (A) can be simplified into single lines. The middle joint wrinkles (B) have an oval pattern that can be drawn with rounded and straight lines. The proximal knuckle wrinkles (C) are minor lines because the underlying extensor tendons push up and "smooth out" the loose skin. Check out the knuckle wrinkles on your own extended fingers.

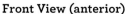

Anatomy of the Lower Leg

The extrinsic muscles originate on the lower leg but send their tendons across the ankle onto the foot. The extrinsic muscles of the lower leg originate on the femur, tibia, or fibula and insert onto foot bones via long tendons. They are divided into three groups: anterior, posterior, and lateral compartments.

Front View (anterior)

Tibialis anterior

Extensor digitorum longus

Peroneus tertius

Extensor hallucis longus

Bones The lower leg consists of the thick *tibia* (D) and the slender *fibula* (C). The *tibial tuberosity* (A) and *head of the fibula* (B) are important landmarks at the top, as are the ankle bones, the *inner malleolus* (E) and *outer malleolus* (F).

Muscles (anterior) The anterior portion consists of *tibialis anterior, extensor digitorum longus, peroneus tertius,* and *extensor hallucis longus.* The tendons of these muscles pass downward on the front of the ankle joint and participate in dorsiflexion, inversion, eversion, and extension of the toes.

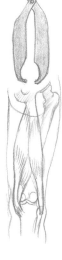

The calf is lower and rounder on the inside than it is on the outside (figure 1).

The hamstring tendons grip below the knee on both sides, almost like a pair of tongs (figure 2).

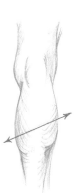

Figure 1 Figure 2

Back View (posterior)

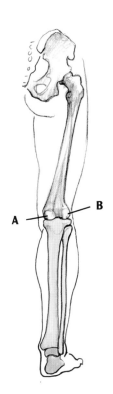

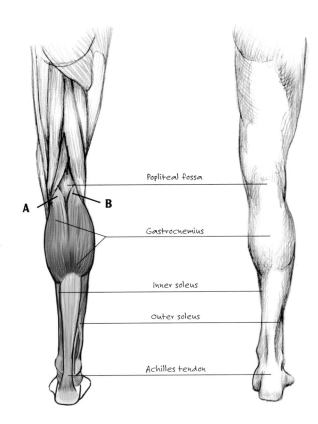

Popliteal fossa

A B

Gastrocnemius

Inner soleus

Outer soleus

Achilles tendon

Bones From the back view, the same leg bones that appear in the front view are visible. Their appearance is slightly altered, however, because the bone attachments in the front are designed to allow muscles to extend, and the back attachment is designed for muscles to flex.

Muscles (posterior) The lower leg's posterior portion features five masses: three larger ones and two smaller. The larger masses are the two heads of the calf: the *gastrocnemius* and the *Achilles tendon*, which connects to the heel bone. The two smaller masses are the *inner soleus* and *outer soleus*. Also, notice the hollow area behind the knee where the calf tendons originate (A and B), called the *popliteal fossa*; this fatty hollow makes deep knee bends possible. In opposition to anterior muscles, which lift the foot up (dorsiflexion), the posterior muscle group points the foot down (plantar flexion).

Side View (lateral)

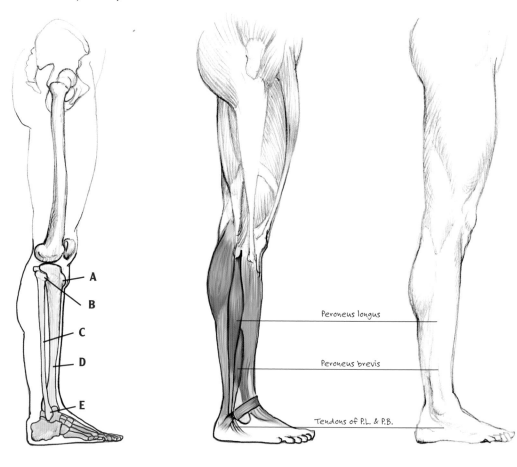

Peroneus longus

Peroneus brevis

Tendons of P.L. & P.B.

Bones From the side view, the *tibial tuberosity* (A), *head of the fibula* (B), *fibula* (C), *tibia* (D), and *outer malleolus* (E) are visible.

Muscles (lateral) The lateral portion consists of *peroneus longus* and *peroneus brevis*. *Peroneus longus* arises from the head and upper shaft of the fibula inserting onto the bottom of the foot (first metatarsal). *Peroneus brevis* arises on the lower lateral shaft of the fibula (covered by *peroneus longus*) and inserts onto the lateral tubercle of the fifth metatarsal (more on this in the next section on foot anatomy). Tendons from both muscles hook behind the *lateral malleolus,* and both help to point the foot (plantar flexion).

Foot Movements

Below are some of the main foot movements we use during daily activities.

Plantar Flexion

Dorsiflexion

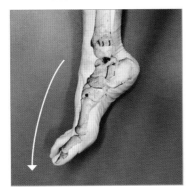

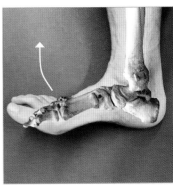

Plantar flexion
Extension of the ankle pointing the foot down (*gastrocnemius, soleus, Achilles tendon, peroneus longus,* and *peroneus brevis*).

Dorsiflexion Pointing the foot up (*tibialis anterior*).

Tibialis Anterior

Extensor Digitorum Longus

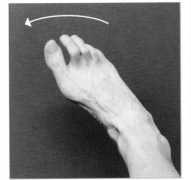

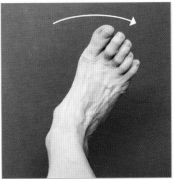

Adduction Foot moves toward the midline of the body (*tibialis anterior*).

Abduction Foot moves away from the midline of the body (*extensor digitorum longus* on top of the foot, and from the lateral side, *peroneus longus* and *peroneus brevis*).

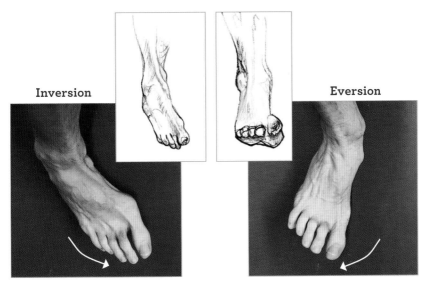

Inversion

Eversion

Inversion Pointing the foot toward the midline of the body (*tibialis anterior*).

Eversion Pointing the foot away from the midline of the body (*extensor digitorum longus*).

Anatomy of the Foot

The foot is designed as a base of support, as a shock absorber upon impact, and most importantly, as a propulsor to move the body during locomotion. Because many of the foot bones, muscles, and tendons are visible on the surface, knowing these bones and tendons is a great help in drawing the feet.

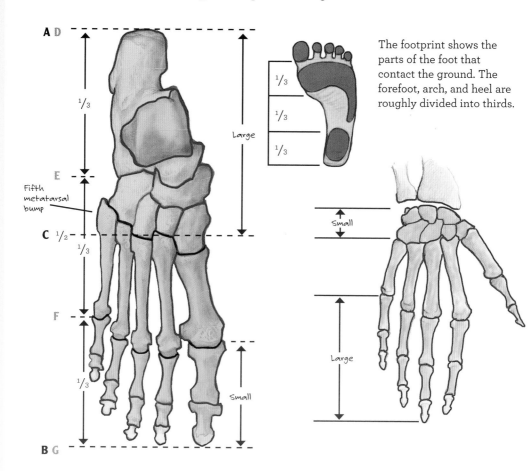

The footprint shows the parts of the foot that contact the ground. The forefoot, arch, and heel are roughly divided into thirds.

Bones Foot bones are very much like hand bones, but their proportions are quite different. Hands are organized from small to large for maximum dexterity, while feet are organized from large to small for maximum stability. Feet are built on a double-arch system, which gives them enough strength and shock absorption to bear the body's weight on any type of surface. Ankle (tarsal) bones are connected to each other with plane joints, which allow just enough movement for feet to flatten and spread out, yet always return to an arch shape.

To construct a foot from the dorsal (top) aspect, divide (A) and (B) to find (C), the halfway mark, slightly beyond the "bump" of the fifth metatarsal. The talus bone is a third of the foot's length (D-E); the cuboid bone to the distal end of the fifth metatarsal is the second third (E-F); and the proximal interphalangeal joint of the fifth phalange to the end of the big toe is the last third (F-G).

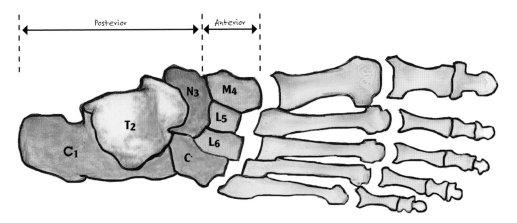

The seven tarsal bones of the ankle sit in two rows (posterior and anterior) and take up nearly half of the length of the foot. Posterior (back) row: *calcaneus* (heel bone) (1), *talus* (2), *navicular* (3); Anterior (front) row: *medial cuneiform* (4), *intermediate cuneiform* (5), *lateral cuneiform* (6), *cuboid* (7).

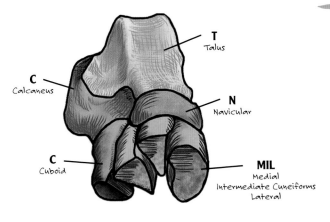

Here is a good way to remember the names of the seven tarsal bones:

Tiger **C**ubs **N**eed **MILC**

Posterior bones The posterior bones, *calcaneus* and *talus*, are the largest of the tarsal bones. The *navicular bone* is visible on the inside of the foot and forms a ball-and-socket joint with the talus, which allows the forefoot a small amount of flexibility.

Anterior bones The anterior tarsals form a strong transverse arch across the foot, yet with their many plane joints, still allow a reasonable degree of flexibility. Viewed from the front, the anterior tarsal bones resemble an old stone arch with *lateral* and *intermediate cuneiform bones* wedged between *cuboid* and *medial cuneiform bones*.

Metatarsals, Phalanges & Joints

Head

Base Shaft

1 B C
2 B C C
3 B C C
4 B C C
5 B C C

A — Plane joints

B — Ellipsoid joints

C — Hinge joints

Metatarsals *Plane joints* (A) connect tarsal bones to the five metatarsal bones. The metatarsal bones are numbered, starting at the ball of the foot. Each of these bones consists of a boxlike proximal base, a long shaft, and a rounded distal head.

Phalanges The rounded distal heads of the metatarsals are *ellipsoid joints* (B). This type of joint provides great movement to the first (proximal) row of phalanges, which can dorsiflex, plantar flex, adduct, and abduct. The second row of phalanges (intermediate) have *hinge joints* (C), which only allow flexion. The third row of phalanges (distal) are also *hinge joints* (C) but are modified to allow both flexion and extension. The big toe's proximal and distal phalanges are connected by a *hinge joint* (C) as well, but is limited to plantar flexion only.

Top View (dorsal)

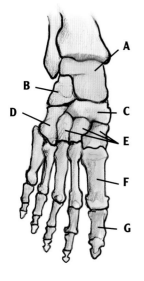

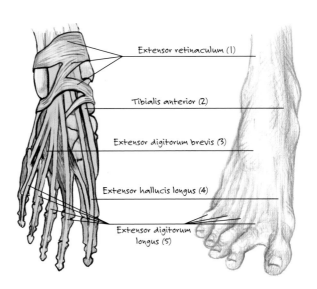

Extensor retinaculum (1)

Tibialis anterior (2)

Extensor digitorum brevis (3)

Extensor hallucis longus (4)

Extensor digitorum longus (5)

Bones As with hands, feet are also composed of three sections: seven tarsal (ankle) bones (A–E), five metatarsals (F), and fourteen phalanges (G). Tarsal bones include the ankle, heel, and instep. The metatarsals of the foot, which end at the ball of the foot, are longer and stronger than the metacarpals of the hand. The phalanges of the toes are shorter than those of the fingers and thumb. While the big toe tends to have a slight upward thrust, the four small toes press and grip the ground.

Muscles When the foot is flexed upward, the following tendons are most evident and are held in place by the *extensor retinaculum* (1): *tibialis anterior* (2), *extensor digitorum brevis* (3), *extensor hallucis longus* (4), and *extensor digitorum longus* (5).

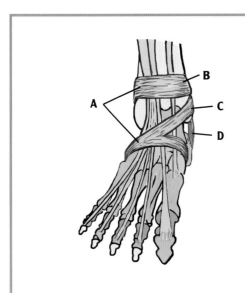

Retinaculum is a thin band of fascia that holds the tendons in place. The ankle has an *extensor retinaculum* (A) and a *flexor retinaculum* (D) to help keep the extensor and flexor tendons in place. The extensor retinaculum has a *superior band* (B) just above the inner and outer malleoli and a Y-shaped *inferior band* (C).

Outside View (lateral)

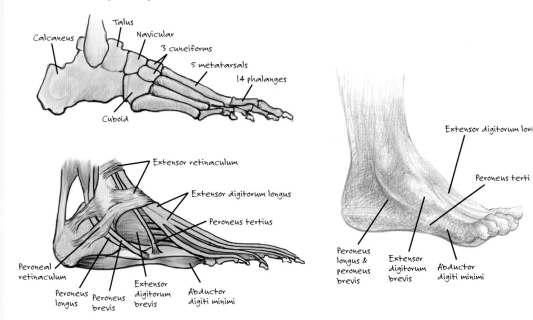

Talus
Navicular
Calcaneus
3 cuneiforms
5 metatarsals
14 phalanges
Cuboid

Extensor retinaculum
Extensor digitorum longus
Peroneus tertius
Peroneal retinaculum
Peroneus longus
Peroneus brevis
Extensor digitorum brevis
Abductor digiti minimi

Extensor digitorum lon
Peroneus terti
Peroneus longus & peroneus brevis
Extensor digitorum brevis
Abductor digiti minimi

Bones From this lateral side view, the medial cuneiform, first metatarsal, and first phalange (big toe) cannot be seen. All other bones are identified.

Muscles From the outside view, the two extrinsic tendons that are held in place by the *extensor retinaculum* bands are the *extensor digitorum longus* and *peroneus tertius*. Beneath these muscles, *extensor digitorum brevis* is evident as an oval-shaped bulge. Another bulge, just behind the little toe, is caused by the *abductor digiti minimi* and runs along the entire lateral edge of the foot.

Hooking behind the lateral ankle bone and held in place by the *peroneal retinaculum* bands are the *peroneus longus* and *peroneus brevis*. During eversion and plantar flexion, their tendons are evident on the outside of the foot.

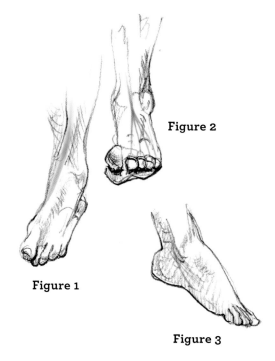

Figure 2

Figure 1

Figure 3

The *tibialis anterior* is an obvious landmark on the inverted foot (figure 1). Dorsiflexion makes visible the *extensor digitorum* (figure 2). Plantar flexion shows the tendons of *peroneus longus* and *brevis* (figure 3).

Inside View (medial)

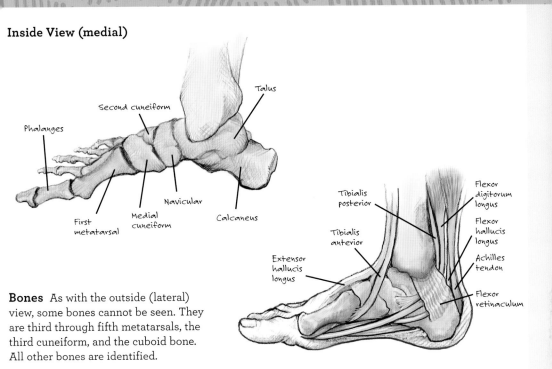

Bones As with the outside (lateral) view, some bones cannot be seen. They are third through fifth metatarsals, the third cuneiform, and the cuboid bone. All other bones are identified.

Muscles The inside (medial) view features mostly extrinsic tendons. Two extensor tendons seen on the top of the foot are the *extensor hallucis longus* and the *tibialis anterior*. Flexor tendons descending from the posterior aspect of the lower leg and inserting into the bottom of the foot are the *tibialis posterior*, *flexor digitorum longus*, and the *flexor hallucis longus*. All are held in place by the *flexor retinaculum*. The *Achilles tendon* drops down from the strong gastrocnemius muscles and is a main actor in plantar flexion.

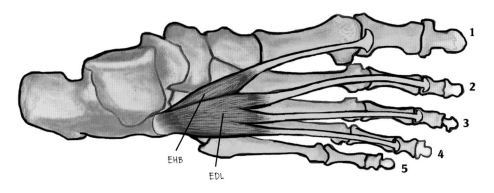

Right foot (dorsal view) The intrinsic foot muscles comprise four layers of small muscles that have both origins and insertions within the foot. On the dorsal (top) side of the foot, there are only two intrinsic muscles, *extensor hallucis brevis* and *extensor digitorum brevis*. They originate on the top of the calcaneus and their tendons attach onto all four phalanges, except for the baby toe (5). Because they originate in the same area, these two muscles appear to be one, but they are actually separate. All other intrinsic muscles originate on the bottom of the foot.

Bottom View (plantar aspect)

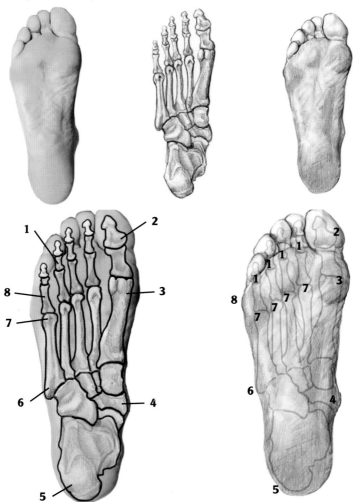

Palpable bony landmarks The purpose of this diagram is to show where the bony landmarks of the skeleton are most palpable on the sole and sides of your foot. Take off your shoes to directly feel the bony landmarks indicated in these drawings. Wherever you cannot feel the bones, it is because the fat pads are doing their job of protecting the muscles and bones.

First, feel just behind the fat pads of your four toes. What you feel there are the *proximal interphalangeal joints* of the middle *phalanges* (1). Now feel the outside of the *distal phalanx* on your big toe (2). It is less protected by fat than its plantar (bottom) side. The prominent head of the *first metatarsal* (ball of the foot) (3) and the *navicular bone* (4) are both also very easy to feel. The *calcaneus* (heel bone) (5), on the other hand, is very well-cushioned, so it can only be felt around its upper areas. On the outside (lateral view) of the foot, the *tuberosity* of the *fifth metatarsal* (6), one of the most important landmarks when drawing a foot, is highly visible and very easy to feel. The heads of the *metatarsal bones* (7 and 3), although not visible, can still be felt under their fat pad coverings. Finally, the *metatarsophalangeal joint* of the *proximal phalanx* (8) can be seen and felt even under the attachment of the abductor digiti minimi muscle.

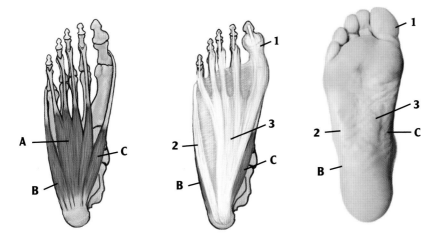

Intrinsic (plantar) foot muscles The intrinsic muscles in the sole are grouped into four layers: The first layer of muscles is the most superficial to the sole and is located immediately underneath the plantar fascia tendons and fat pads. Most of the other intrinsic muscles are located deep in the sole of the foot. The only muscles regularly seen are in this first layer:

A. *Flexor digitorum brevis:* A large central muscle that flexes the second to fifth toes.
B. *Abductor digiti minimi:* Responsible for flexion and abduction of the fifth toe.
C. *Abductor hallucis:* Abducts the big toe (spreads it outward).

The bulging form of the *abductor digiti minimi* is concealed for the most part by plantar fat, which blends with the form.

Plantar aponeurosis The plantar aponeurosis is a strong fibrous band of fascia that extends along the bottom of the foot. It lies on top of the foot muscles, passing from the heel toward the toes. It assists in maintaining the longitudinal arches of the foot and provides areas for muscle attachment. The lateral and middle portions of this ligament can be faintly seen on the surface of the foot.

1. *Fibrous digital sheath, first distal phalanx*
2. *Lateral plantar fascia*
3. *Middle plantar eminence*

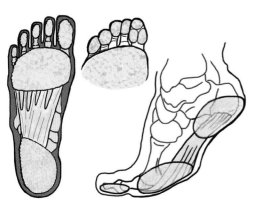

Surface of the sole (plantar fat pads) The surface of the sole is formed by thick pads of fat and fibrous tissue rather than muscle. Fat pads protect the plantar fascia, bones, muscles, nerves, and blood vessels of the feet by absorbing and dissipating energy from impact when we walk or run.

Phalangeal fat pads cushion the toes. There are three lumps of fat on the big toe. *Metatarsal fat pads* protect the heads of the five metatarsal bones. *Calcaneal fat pads* soften impact on the heel.

Drawing Techniques

The Picture Plane

The picture plane is like a window frame through which an artist sees the three-dimensional world. It also corresponds to the edge or borders of an artist's drawing or painting surface.

The best way to understand the picture plane is to see it in action. Using a dark erasable marker on an upright piece of plexiglass, stand in one spot and—without moving your position—draw the exact outlines of what you see.

This tracing is much the same as how you will draw on your paper; except on your paper, the correct angles will be manually transferred to your drawing surface using a stretched-out arm and pencil for measuring purposes. This is how hand-eye coordination is developed and is known as freehand drawing.

A "double L" finger viewfinder For more advanced artists, fingers can make a great viewfinder too. Stretch your index and middle fingers on both hands into "L" shapes. Overlap and slide them together or apart to match the format of your paper (horizontal, vertical, etc.). Then, without changing the format, move your finger viewfinder closer or farther to determine a composition.

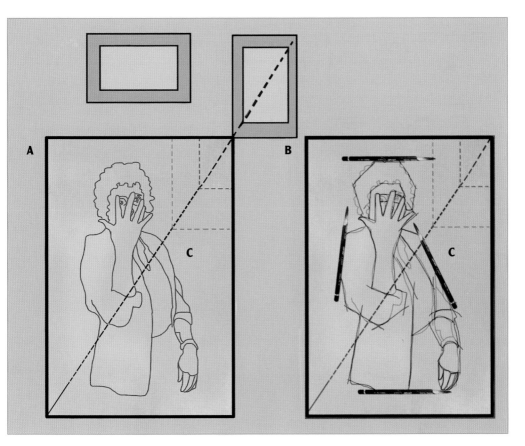

Plexiglass Drawing Surface

Rectangle (A) is the plexiglass tracing. Rectangle (B) represents the corresponding pencil drawing on paper (note mostly straight lines). The broken diagonal line (C) running from the upper corner of the vertical viewfinder to the lower corner of the plexiglass tracing shows how to keep border proportions (red broken lines) consistent when enlarging the viewfinder's proportional format onto your paper.

Things to Remember When Drawing...

- Begin a drawing with very light straight lines (more about this in the next section).
- See negative shapes as well as positive shapes.
- Measure carefully and take your time.
- Continuously drop plumb lines to find vertical alignments between top and bottom.
- Continuously check right and left horizontal alignments.
- Do as much as possible by eye, but when something looks off, double-check by measuring.

Constructing a Viewfinder

Start with any size square of plexiglass (a small size is handy for toting). Draw a grid with a permanent marker and adhere Velcro® to the edges. Cut another strip of plexiglass the same size as a Velcro strip, and then fasten them together. You can then use this Velcro-plastic strip as a movable picture plane for various rectangular borders and for finding angles to transfer to your drawing.

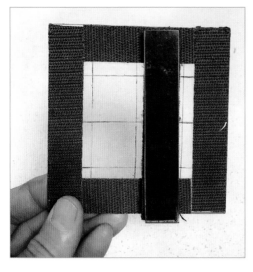 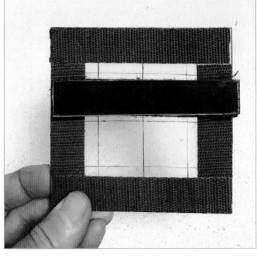

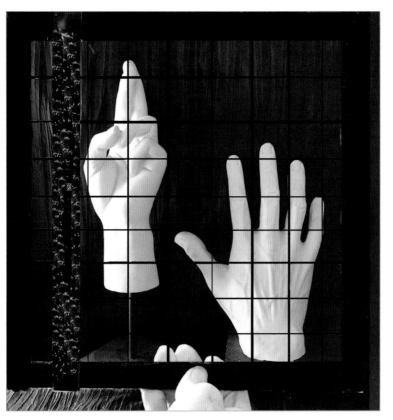

This larger version of the viewfinder shows how to compose a square, vertical, or horizontal format. When a viewfinder is held close to the eyes, the cropped view is wide. When held farther away, as in this composition, the subject is close-cropped and larger.

Finding Measurements with a Pencil

The secret to getting pencil measurements as accurate as proportional dividers (see below) is to keep one eye closed, stretch out the arm as far as possible (steady the elbow with the other hand), and keep your pencil perpendicular (90 degrees) to the line of vision.

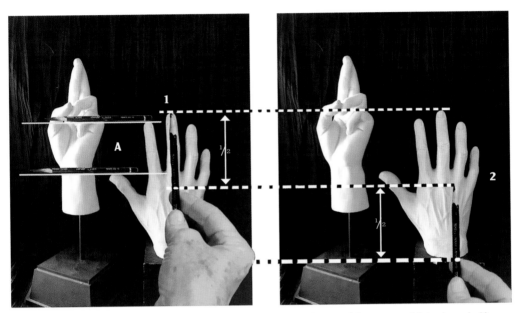

Vertically, from pencil tip to the knuckle (1) is a halfway mark. Knuckle to wrist (2) is also a halfway mark. Horizontally, the two pencils on the left (A) show how one hand relates to the other (i.e., the thumb of the open hand lines up with the wrist of the other hand; the upper pencil lines up with the index fingertip of the open hand and the baby-finger knuckle on the crossed-finger hand).

A proportional divider is used to transfer scale in a more direct way than pencil measuring. Place the small end of the divider on the width of the hand in your reference image (or with an outstretched arm when working from a live model). Then, without changing the proportion, place the large end of the divider onto your paper. This scales up the drawing using the exact proportions of the photo. This handy divider is made by Accurasee Art Products.

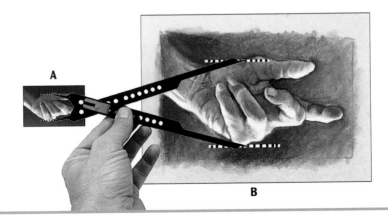

Shapes

In music, compositional silence between notes makes or breaks a symphony. The same is true with drawing. The way empty space is designed around the forms can make or break the composition. In addition, learning to see the negative space can make drawing easier.

For instance, when you carefully draw the negative space around a "difficult" foreshortened form, you are also inadvertently drawing the edge of the positive form. Therefore, when a negative shape is drawn correctly, the positive form is correct as well.

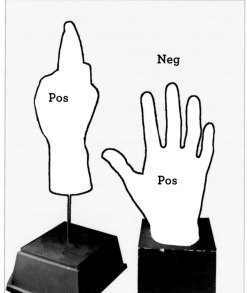

Drawing Positive & Negative Shapes

Because hands and feet are so dynamic, more often than not, they are also foreshortened. That is why so many people find them difficult to draw. The solution to this difficulty lies in a combination of learning how to measure and training the eye to recognize negative shapes.

It is hard to focus on the "empty" spaces around an object, but if you take a moment to think of something else the shape resembles, it will begin to focus into an actual shape you can remember and draw.

The positive shapes of these outstretched fingers resemble a maple leaf.

This hand comes to life as a bug-eyed alien (just having a little fun)!

These negative spaces resemble a barking dog, with an open mouth between the thumb and fingers.

The space between the thumb and forefinger create a simple wedge with one side shorter and more curved than the other. The spaces between the next two fingers are slender "V" shapes.

Perspective

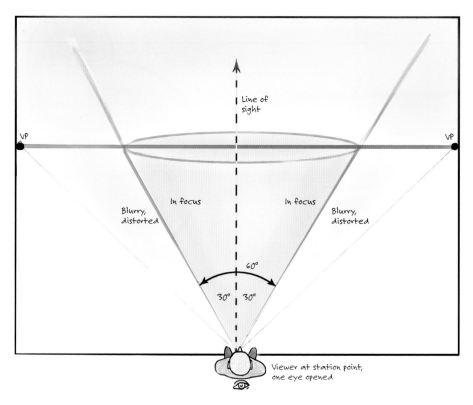

Line of sight

VP

VP

In focus

In focus

Blurry, distorted

Blurry, distorted

60°

30° 30°

Viewer at station point, one eye opened

The Cone of Vision

Along the periphery of one's line of sight there is a place where clear vision ends and blurriness begins. In perspective drawing, this area of distortion is called the "cone of vision" and is shown here as an orange cone viewed from above. This conical boundary represents a viewer's 60-degree cone of vision, with 30 degrees of focus on either side of the forward line of sight. Anything outside of this cone will be distorted and out of focus. Using linear perspective, the way to avoid this distortion is to place the vanishing points well outside of the cone of vision, and sometimes even outside the picture plane itself.

Horizon line Eye level is an imaginary line that is horizontal to your line of sight; it is the actual height of the viewer's eyes when looking at an object. Some say "horizon line" refers to outdoor drawings and "eye level" to indoor drawings, but either way, they are one and the same.

Ground plane The horizontal plane receding from the baseline of the picture plane toward the horizon.

Vanishing point The spot (or spots) on the horizon line toward which the receding parallel lines diminish.

Station point The position of an observer.

Cone of Vision

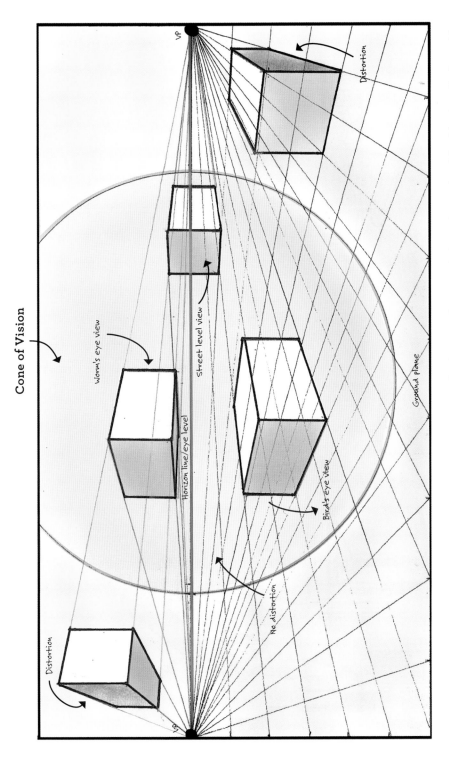

This drawing shows the horizon line at street level. If a viewer were to lie down on the ground plane, the eye level (and horizon line) would be low, like a "worm's-eye view." If raised, their point of visual reference would become a "bird's-eye view." Note how much distortion (red sides) occurs outside the cone of vision where both blocks are too close to their vanishing points. Notice how the blocks inside the cone of vision look perfectly normal.

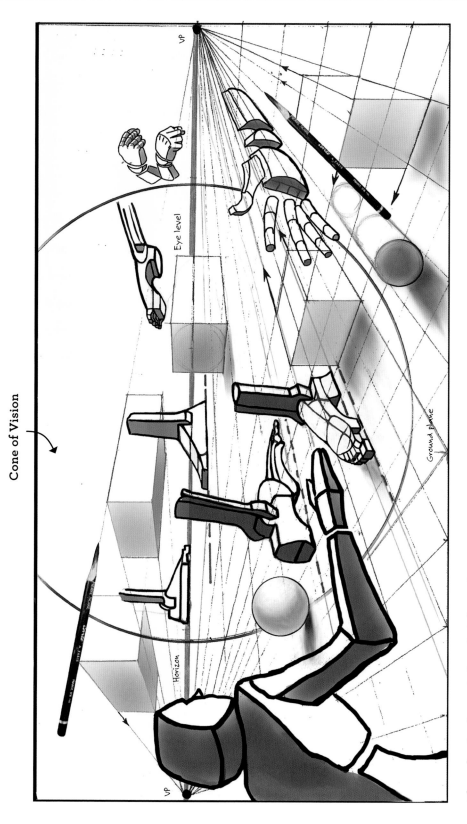

Cone of Vision

Three basic shapes in hands & feet The only three shapes you need to know for drawing hands and feet are cylinders, blocks, and spheres. The surreal scene in this diagram shows all three forms plus some blocked-in hands and feet, dutifully following the laws of linear perspective, including a blocky viewer's eye level placed exactly on the horizon line where it belongs.

Foreshortening

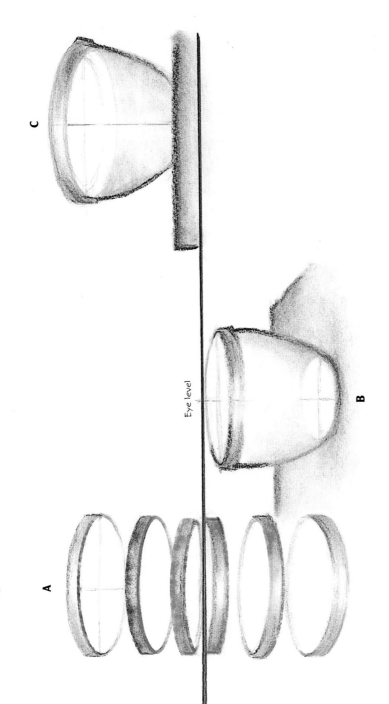

Eye level

Ovals

A. Ovals seen from above or below the horizon line get progressively rounder as they move higher or lower.

B. This is a "bird's-eye view" of a cup, with a high horizon line. (The lower ellipse is rounder than the upper one.)

C. Now the cup is seen with a low horizon line from a "worm's-eye view." Because the sides of the table are above eye level, the bottom of the cup is hidden.

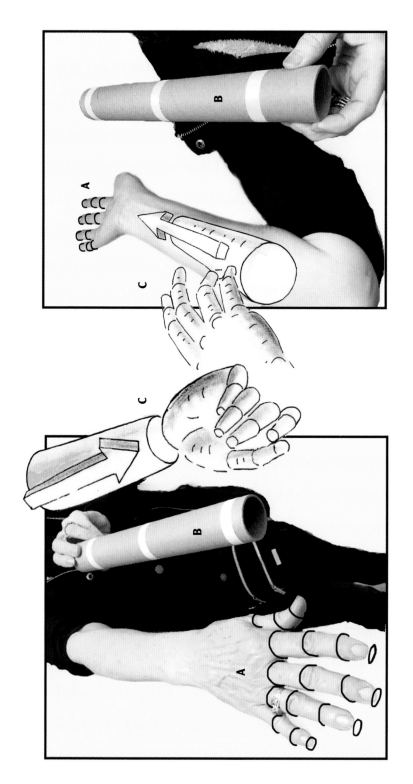

Cylinders

Cylinders are the basis for many anatomical forms—especially fingers and toes—so it is worthwhile to practice drawing them. Find a paper towel roll, add several strips of tape, and sketch it from many angles. Notice how the oval direction of the ellipses in the fingers (A) and tape over the rolls (B) both communicate the best strokes to use when shading. The direction of the ellipses (C) also indicate whether arms and hands are facing toward or away from the viewer.

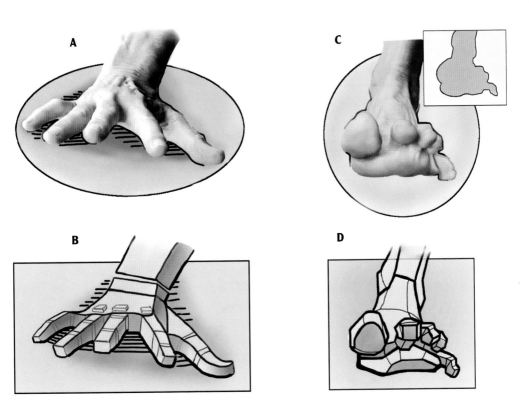

Blocks

The fingers on this hand (A) look more like blocks than cylinders, so blocks (B) are the best way to depict them. A blocky hand not only shows solidity but also the hand's orientation toward the viewer. But as the left brain constantly weighs in with preconceived visual conceptions, foreshortened fingers are hard to draw as they actually are. The solution? Rather than drawing the fingers as positive shapes, draw the negative shapes between them (black horizontal lines).

The foot (C) is even more ambiguous than the hand, because none of its foreshortened toes (except the baby toe) show up in a silhouette (see inset), and a strong, well-defined silhouette is the basis of a strong drawing. To restore graphic clarity, the toes are boldly drawn as definite, blocky shapes, and the top of the foot is clearly depicted as separate from the shin and ankles.

Foreshortening with overlapping
These 20-minute pencil sketches were drawn from a live model in a sketch group. The line drawings next to each are intended to clarify those parts of the pencil sketches where overlapping occurred. Overlapping is especially helpful when forms are foreshortened and is accomplished with either a darkened line or a stark difference in values. Compare each pencil drawing to its accompanying line drawing to see how and where one plane overlaps another. Areas that overlap are lined with red.

Seeing Values

Hands and feet present themselves to the viewer as areas of color, shape, and value. Because the drawings in this book are mostly black, white, and shades of gray (or drawn in tonal Conté values), you must translate the actual colors you see in photos or life into shapes of corresponding values.

Many artists simplify nature's hundreds of subtle values into a scale of ten values, but five is plenty—and fewer values actually make a stronger statement: 5 = highlight, 4 = low light, 3 = midtone, 2 = low dark, and 1 = dark. Because flesh tones are never pure white or pure black, this value scale does not include pure white or pure black either.

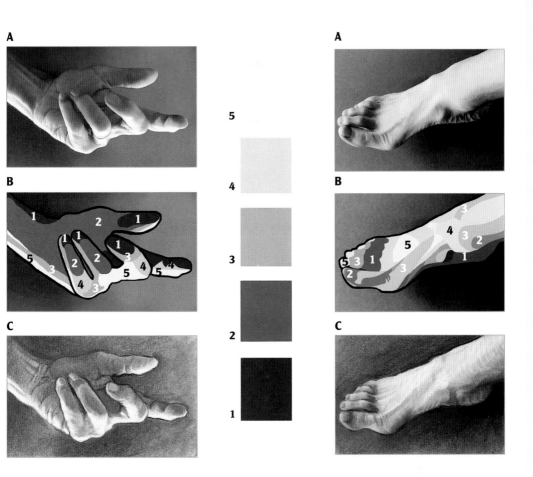

At top are the actual hand and foot photos I worked from (A). The value drawings (B) show how to simplify and label the light, middle, and dark tones. The Conté drawings (C) correspond as closely as possible to the value analysis above.

Low & High Contrast in Value

When studying your subject and choosing tones from the value scale, it is important to determine how much contrast you see between lights and darks. If a subject consists mostly of grays (i.e., the lights are not too bright, and the darks are not too dark), it is said to have low contrast. On the other hand, a high contrast subject has very bright lights, dark darks, and various shades of gray. Both of the drawings above are high contrast because their backgrounds are dark.

Step-by-Step Drawings

Contour Drawing

Contour drawing is a linear drawing process where depth is achieved through varying line pressure and overlapping rather than through light and dark shading. In these examples, without looking at the page, I moved my pencil only where and when my eye was moving. I only looked at the paper when I lost my concentration or needed to find a new position on the drawing.

Sit down with a small sketchbook, pen, or pencil and pretend that the tip of your pencil is touching the edges of your hand or foot. As much as possible, try not to lift your pencil, while focusing mainly on the negative shapes between fingers and toes. Each of your drawings should only take a few minutes but will require a lot of concentration.

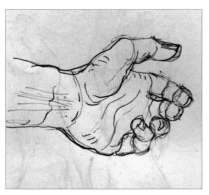

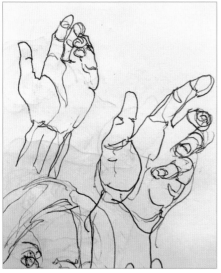

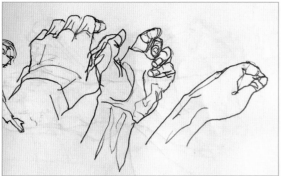

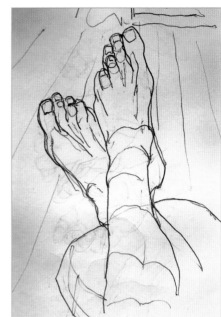

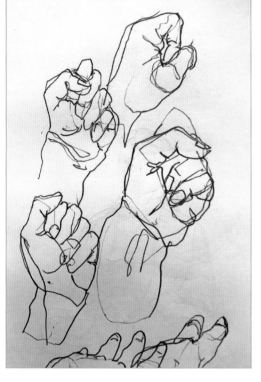

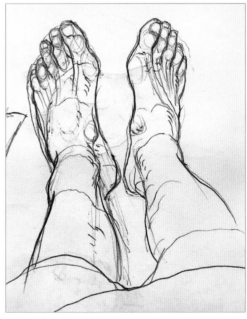

The foot drawings on this page took a little longer than the hands, as they include a few anatomical landmarks, such as the extensor tendons, navicular bones, first metatarsal heads (balls of the foot), and a few toe details. Note how I've also indicated the semi-rounded shape of the shin bones and lower-leg muscles with cross-contour lines. When drawing your own hands and feet, look back at the anatomical section to refresh your memory of which anatomical landmarks you are seeing.

Structural Drawing

In contrast to contour drawing, the structural approach replaces the complex anatomical forms with simplified geometric forms, such as blocks, cylinders, and spheres. The reason for this approach is that basic forms are much easier to draw than the complex forms they resemble. Here the palm and fingers are conceived as simple blocks, but they could just as easily have been drawn as cylinders. I achieved three-dimensional volume using light- and dark-colored Conté pencils on a warm midtone paper.

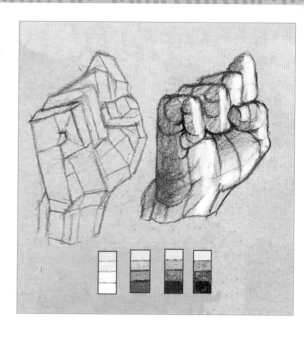

A Combination of Structural and Contour Approaches

In this example, I started by drawing the fingers, knuckles, and fat pads as spheres and cylinders but then added curvilinear contour lines with a single light source to add volume. Compared to the previous drawing, this fist is one step closer to becoming a realistic rendering.

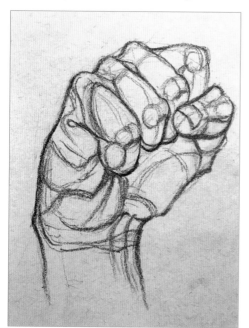

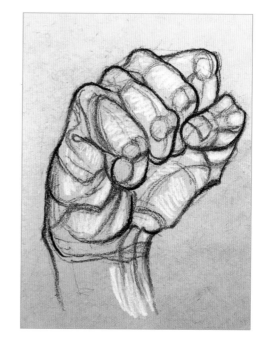

Drawing a Clenched Fist on Toned Paper

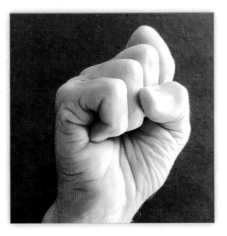

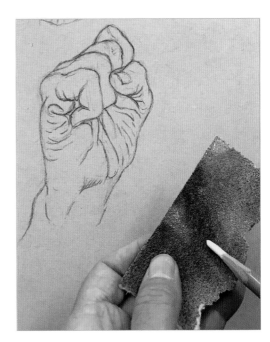

Using sepia and white Conté pencils, I start this realistic rendering of my own hand with simple dark contour lines.

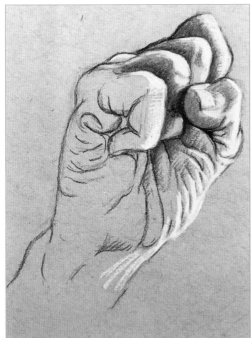

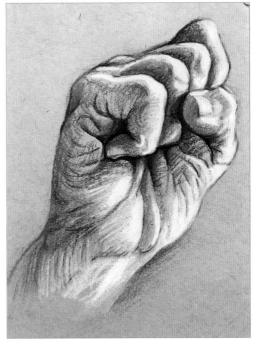

As white is added, my conception becomes more structural and blocklike, which increases the sense of three-dimensionality.

Notice how despite the many small hatching strokes, the warm midtones of the paper remain untouched, especially between the light and dark areas on the palm and fingers.

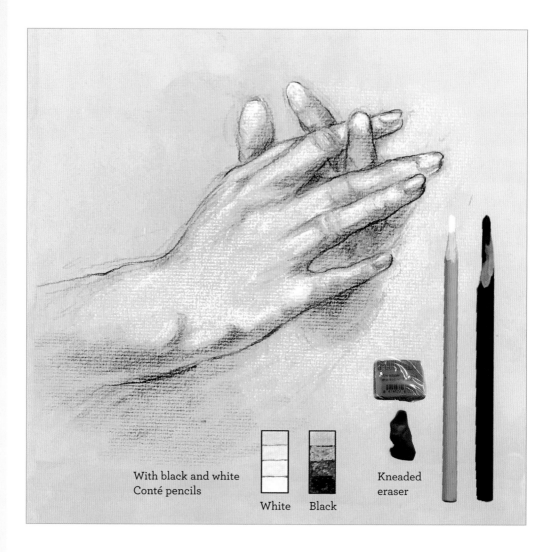

With black and white
Conté pencils

White Black

Kneaded
eraser

Drawing Hands on Gray-Toned Paper

This hand was constructed in the same way as the fist but with black and white
Conté pencils. Dark and light values were created solely with pencil pressure in
conjunction with an occasional tamping of the kneaded eraser. The two value scales
show the wide variety of light and dark values that are possible simply by varying
pencil pressure. Because the gray-toned paper shows through in so many areas, this
drawing has an atmospheric sense of softness.

Drawing from Life

20-minute Life Drawings: Conté, Green Pastel, Charcoal & Pencil

One of the best ways to improve drawing skills is to attend three-hour life drawing sketch groups, where a live model holds a variety of timed poses ranging from 2-minute gestures to 5-, 10-, and 20-minute poses. Sometimes a 20-minute pose is extended to a 40-minute pose.

Each hand or foot on this page was drawn in 20 minutes or less. The reddish hands and feet were drawn with Conté pencils, the greenish-black drawings with vine charcoal and green pastel, and the gray drawings with a mechanical 4B graphite pencil.

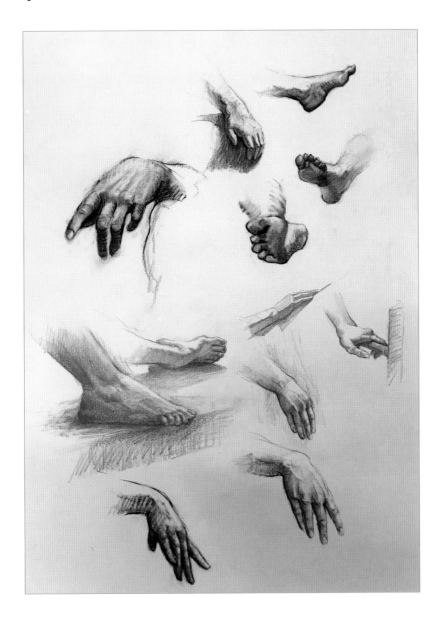

2-minute Poses: Vine Charcoal & Green Pastel

This page shows a cluster of 2-minute warm-up gestures and one 20-minute pose on a white newsprint pad propped on my lap during a sketch group.

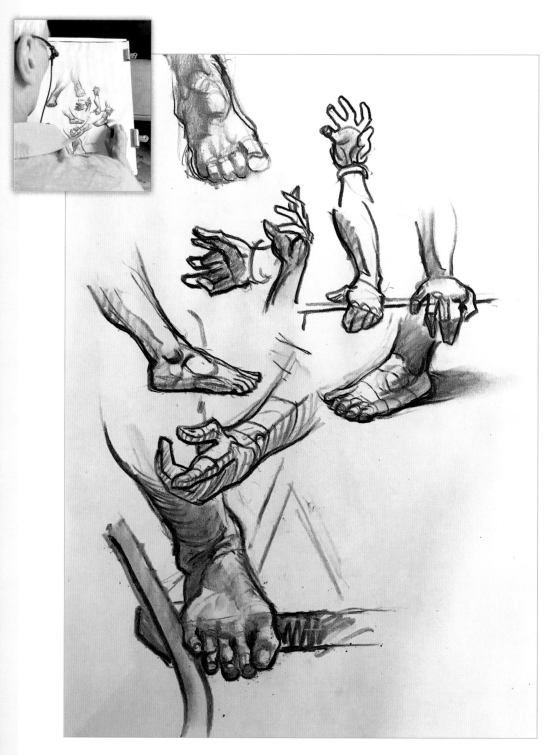

2-minute Hand Gesture

Any drawing, whether it's a 2- or 20-minute pose, is begun the same way—with a gesture. Gestures are all about quickly capturing the movement and spirit of a pose while warming up. They deal only with basic angles and negative space, not details.

 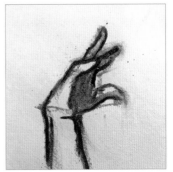

With a green pastel, draw the forearm and hand as a flat 2-dimensional shape, using only straight or slightly curved lines.

Now, with a stick of vine charcoal, overlap the index finger and thumb to show that the palm and other fingers are in front.

As the 2-minute timer goes off, quickly indicate the shadow side of the hand. Even without details, this gesture is still expressive.

20-minute Foot Pose

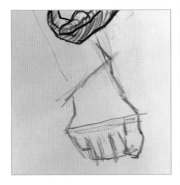 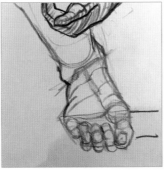 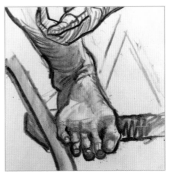

This 20-minute pose is also begun as a gesture. The inner ankle sits higher than the outer ankle (remember HI/LO = High Inside/Low Outside). This characteristic of legs is indicated by a faint diagonal construction line. The horizontal construction line in front of the foot relates the head of the first metatarsal (ball of the foot) to the head of the fifth metatarsal (bulge at the baby toe).

Now further render the forms with vine charcoal cross-contour lines on the top of the foot and spheres to show the toe knuckles.

Lastly, darken the shadow shapes with charcoal and blend them with a stump. A kneaded eraser is very helpful for gently picking out nuances of reflected light in the shadow. Vine charcoal smears easily. If you like your drawing and it is on white paper, spray it with a fixative to preserve it.

20-minute Pencil Sketches

All of the hands and feet on this page were drawn with a mechanical 4B graphite pencil and modified with a kneaded eraser. At times, when the poses aren't that great or the hands and feet are totally hidden, it's necessary to find a constructive alternative during the 20-minute pose. On this page, there was one particular pose where the model's hands and feet were completely hidden by drapery. The solution? I ignored the model and drew my own hand instead (A). The foot (B) and hand (C) chosen for the following two demonstrations both have challenging foreshortening and cast shadow patterns.

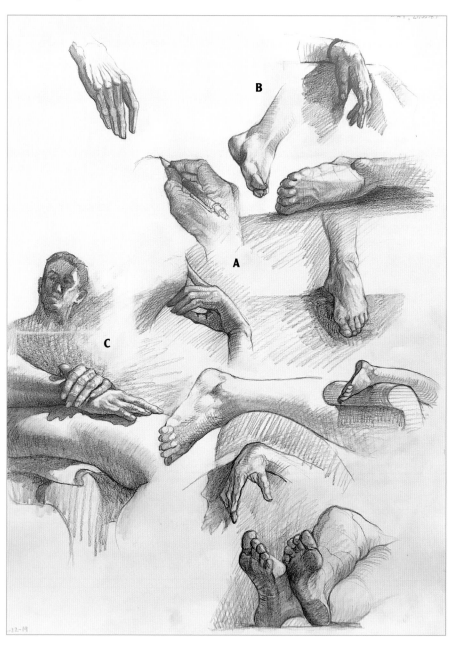

20-minute Foot Demonstration (B)

Carefully draw the outer and inner contours of the foot.

With a sharpened lead, use roundish pencil strokes to follow the cylindrical shape of the shin. To show the flatness of the foot's top and bottom planes, use straighter strokes.

Blend all of the lines together with a stump.

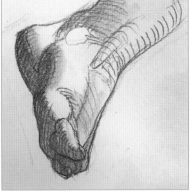

Slightly darken the side of the foot so it will represent the correct value of flesh.

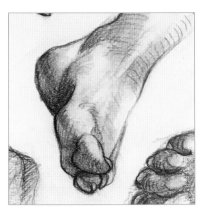

With a kneaded eraser, pick out certain light areas to indicate anatomical landmarks, such as the tibialis anterior, head of the first metatarsal (ball of the foot), navicular bone (sits over the arch), and calcaneus (heel bone). Beginning at the big toe, notice how each form overlaps the one behind it. This technique of overlapping, in conjunction with form following strokes, is one of the main reasons this foot looks so foreshortened.

20-minute Hand Demonstration (C)

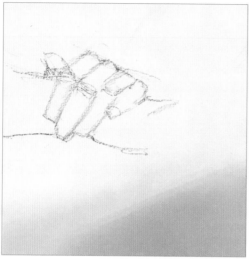

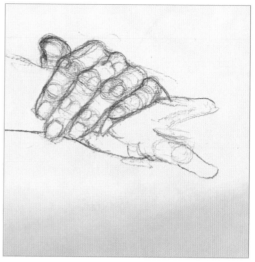

Draw the outside contours of the hand and arm without details.

Darken the contour lines of the fingers on the top hand, draw light cylindrical lines around the fingers, and use spheres for the knuckles. Begin sketching in the other hand with simple, light construction lines.

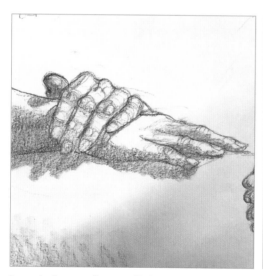

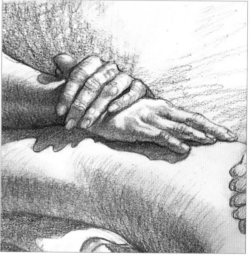

Loosely draw in the overall shapes of the form and cast shadows, add a darker value within their shapes, and blend them with a stump.

Refine the cast shadows by placing a line around their edges on both forearm and leg. Show reflected light in the form shadows by slightly tamping them with a kneaded eraser. Add form-following strokes over the blended areas to give roundish fingers, forearm, and leg a more convincing sense of volume. Clean up the directly lit areas with a kneaded eraser and surround the lights with shadows to heighten the sense of chiaroscuro (light and dark).

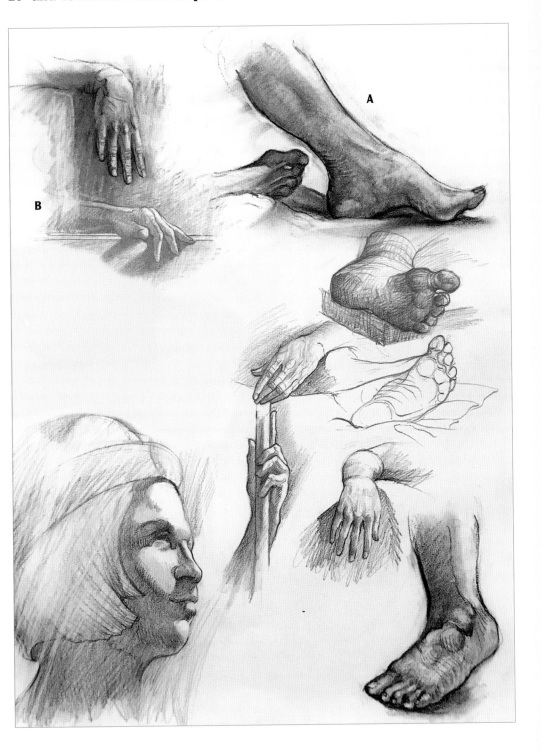

40-minute Foot Demonstration (A)
This foot in profile (with its super-
high arch) is very different from the
foreshortened foot we just analyzed.
With a stick of green pastel, lightly
gesture in the shape of the foot.
Look at the skeleton on the left to
see how the placement of the inner
malleolus (inner ankle) and head of
the first metatarsal (ball of the foot)
correlate to the drawing at this
early stage.

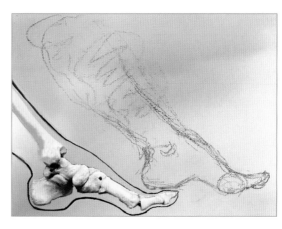

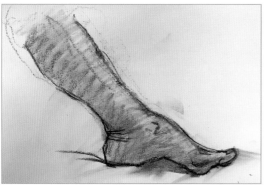

Now switch to a vine charcoal stick. Redraw the
outside contours, add wrinkles over the heel, and
tone the overall leg and foot with green pastel and
vine charcoal. Later on, lights can be lifted out with
a kneaded or plastic eraser.

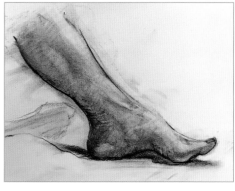

At this stage, use a regular charcoal pencil
and blend the tones together with a stump.
A kneaded eraser pinched together to give
it a sharp point is used as a drawing tool.
Begin lifting out light areas representing
anatomical landmarks, such as the tibialis
anterior, extensor hallucis longus, and the
reflected lights that show the gastrocnemius
muscle.

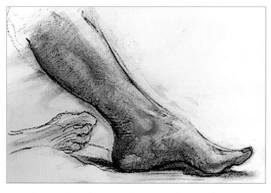

Now begin sketching in the toes of other foot with
vine charcoal and green pastel.

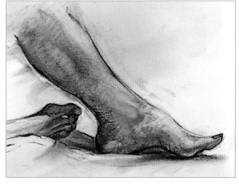

Use the blending stump to show the cast
shadow over the toes and lift out lighter
areas, such as the big toe's nail and the
extensor digitalis tendons.

20-minute Hand Demonstration (B)

In the prior hand demonstration, the cast shadow fell directly onto a well-lit leg, giving it a hard edge. In this drawing, the cast shadow falls obliquely onto the table's side, causing its edges to become diffuse. Knowing about "edge distinctions" such as these are the secrets that professional artists use for final finishing touches.

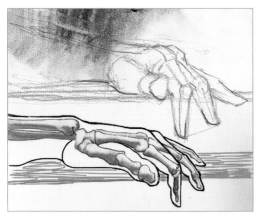

The fingers are outlined as simple blocky shapes, and the roundish knuckles are spheres. Look at the skeleton next to this drawing and compare the two. Even though the thumb is more foreshortened than the skeleton, you still get an idea of how much the bones influence this drawing.

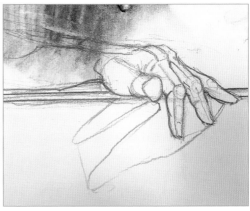

Further darken the contours of the fingers and sketch in the shape of the cast shadow.

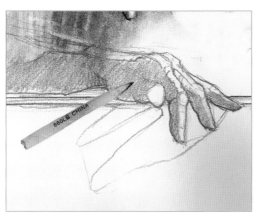

Add a shadow of toned strokes with the pencil and blend them with a stump.

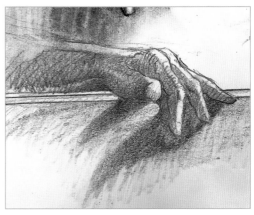

Continue to blend with the stump and soften the edges of the cast shadow. Lighten the top of the forearm and fingers with a kneaded eraser and soften all edges except for the thumb and tops of the fingers. This softening will direct the viewer's eye to the focal point, the part of the hand that is most interesting.

Working from Photographs

Beginners often find it easier to work from photos than from life, but as skills increase, it is best to do both. The main difference between drawing from a live 3-D model and 2-D photographs is that photos, like drawings, are already two-dimensional and therefore do not require the further step of "seeing" and translating three-dimensional forms onto a flat picture plane.

"Just begin and the mind grows heated; continue, and the task will be completed!"

—Johann Wolfgang von Goethe

Three Ways to Begin Drawings from Photos

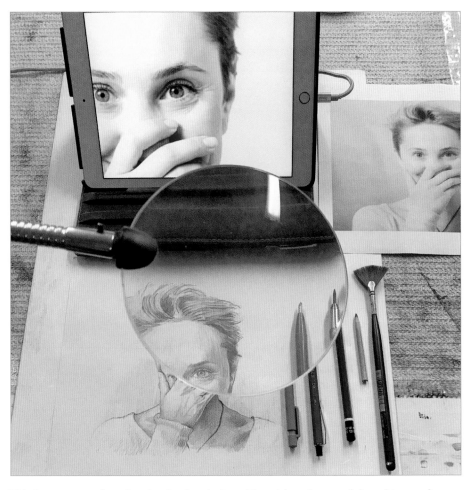

This is my setup when drawing freehand: 1) a tablet with an image of the subject and a flex-neck clamp-on magnifying glass for working on small details; 2) a tiny plastic eraser (green handle) for erasing small details; 3) a 2B mechanical pencil for most of the drawing; 4) a softer 5B pencil for making rich darks; 5) a blending stump and a soft fan brush to clean up eraser crumbs; and 6) the all-important kneaded eraser (which I use an awful lot) is not shown here.

1. Drawing Freehand

Drawing freehand from a photograph is a good way to maintain hand-eye coordination skills because it is very much like actual life drawing. The main difference is in measuring. When working from a photo, your pencil actually touches the flat photo rather than sighting and measuring from afar. Other than that, the process is very similar to what was covered in the previous section (page 55).

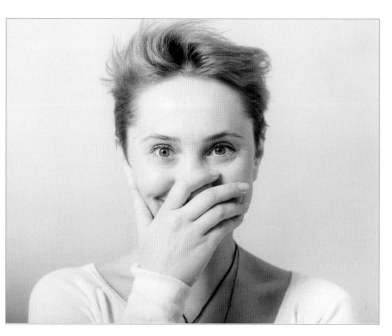

Select an image to draw from. Continuously hone your mechanical pencil on a sanding block to keep it sharp throughout the drawing.

Using light construction lines, look for basic facial proportions, such as the $1/3$ divisions between the hairline, eyebrows, and chin. First analyze the hand in terms of anatomy, cubes, cylinders, and cross-contours to draw it convincingly.

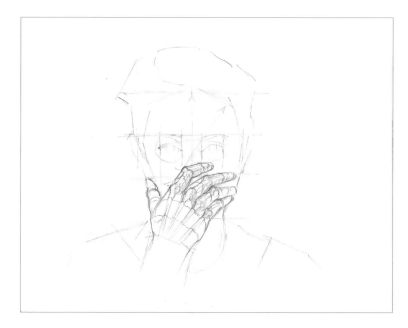

2. Transferring with a Grid

This is the type of grid I use when enlarging small studies into large murals. Compared to "normal" grids with only vertical and horizontal lines, I find this grid superior because its diagonals add an extra point of reference. The most important thing to remember when you make a transfer grid is that both the photo and your drawing must be scaled up using the same proportions or your final transferred image will be skewed (see pages 52-54).

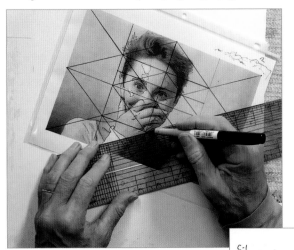

After printing an 8.5" x 11" black-and-white copy of the colored image, place it inside a plastic sleeve. Draw lines onto the sleeve with a fine-tipped Sharpie®. Because Sharpies are alcohol-based rather than water-based, they draw nicely on smooth plastic surfaces without smearing. The lines must be placed exactly or errors will begin to multiply, and the two final grids will not match up the way they should.

This type of grid can be made as simple or complex as necessary. Notice how there are not very many lines around the edges; rather, keep most of the horizontal, vertical, and diagonal lines close to the features and hands where they are most essential for drawing precise parts.

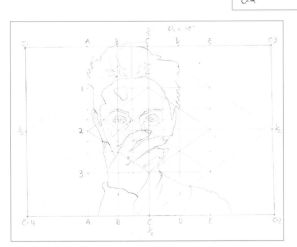

This is what the finished drawing looks like after carefully copying the placements on the gridded photo, and it has more than enough detail to get started. Drawing with a grid is not about making a finished drawing; it's about getting the basic parts placed correctly.

3. Tracing on a Light Box or Window

If using fairly thin white or toned paper (even 140 lb. watercolor paper will work), the quickest way to lay out a well-proportioned image is to tape a photo under your paper on a light box or against a brightly lit windowpane and lightly trace the image's outlines with a graphite or pastel pencil.

This is what the image under my drawing paper looks like when placed on a light box. Alternatively, you can use a graphite transfer sheet if the paper is too thick to see through.

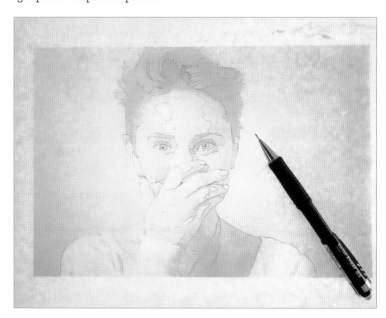

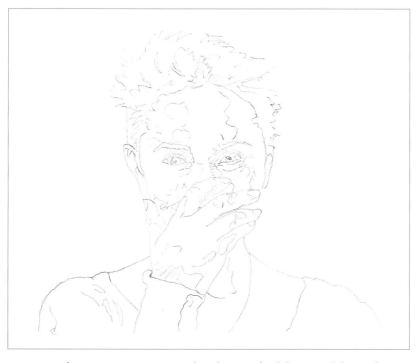

Trace over the image to create an outline for your final drawing. (This outline is used for the step-by-step graphite drawing demonstration on pages 84-87.)

Step-by-Step Hand Drawings

Graphite mechanical pencil, blending stump & two types of erasers

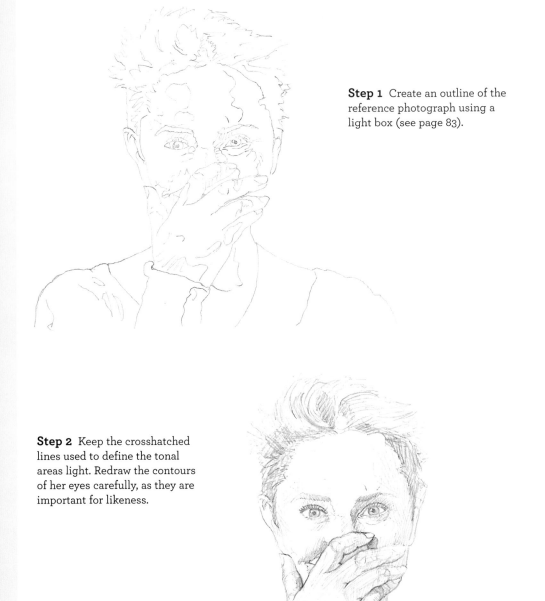

Step 1 Create an outline of the reference photograph using a light box (see page 83).

Step 2 Keep the crosshatched lines used to define the tonal areas light. Redraw the contours of her eyes carefully, as they are important for likeness.

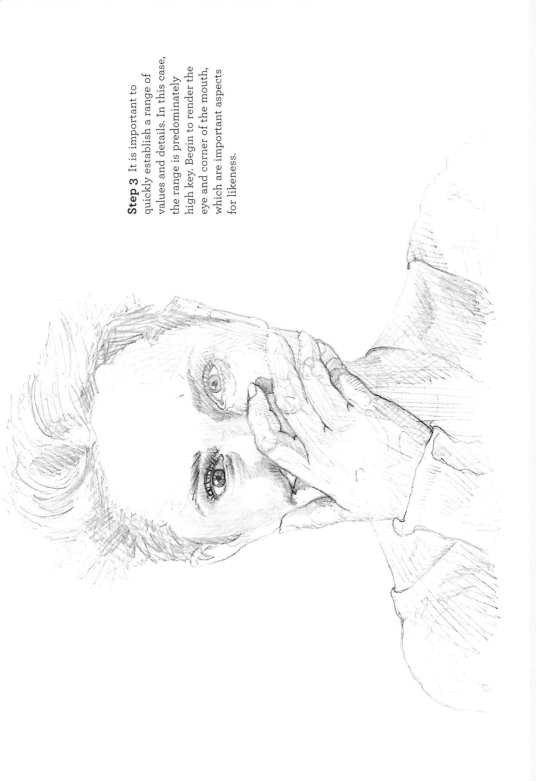

Step 3 It is important to quickly establish a range of values and details. In this case, the range is predominately high key. Begin to render the eye and corner of the mouth, which are important aspects for likeness.

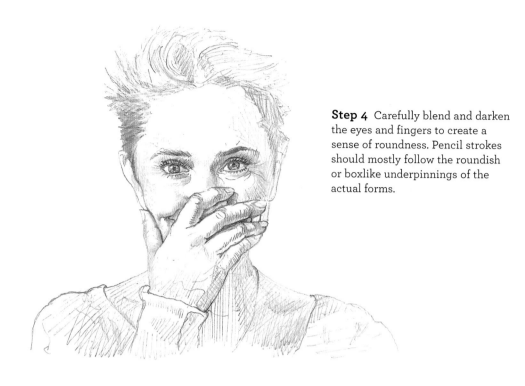

Step 4 Carefully blend and darken the eyes and fingers to create a sense of roundness. Pencil strokes should mostly follow the roundish or boxlike underpinnings of the actual forms.

Step 5 In addition to darkening, blending, and further crosshatching, start lifting out lights with the kneaded and plastic erasers. (Note the cross-strokes on her right cheek and the subtle crow's-feet next to her eyes.)

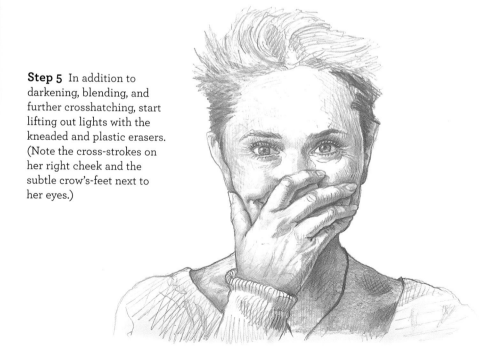

Step 6 Finally, soften and lighten all crosshatch lines with the stump and kneaded eraser. As a last touch, add a subtly rounded background shape to echo the roundish head.

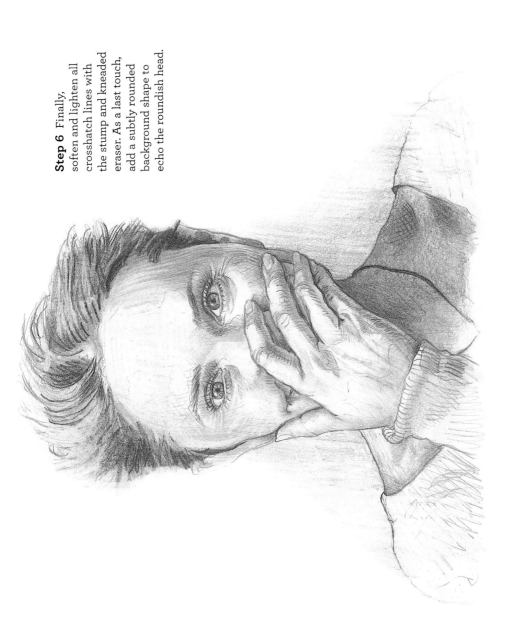

Conté charcoal pencil, blending stump & two types of erasers

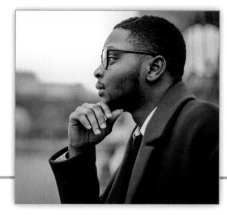

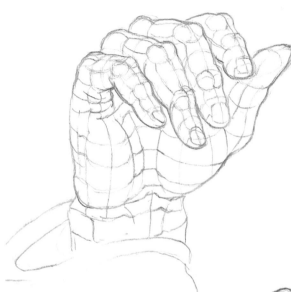

The best way to understand what a hand is doing (before starting the final drawing) is to analyze it larger with contours, cross-contours, and anatomical landmarks. Note the thenar eminence, hypothenar eminence, indention of the palm, and volumetric shapes of the fingers and knuckles.

As a second stage, to better understand stroke directions and value distribution over the volumetric forms of the hand, draw in the correct values and indicate their stroke directions (especially as subtle nuances will not show in the final small rendering). This is a great way to practice your knowledge of the hands and can be done with many poses.

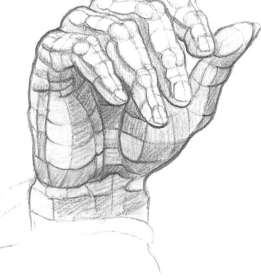

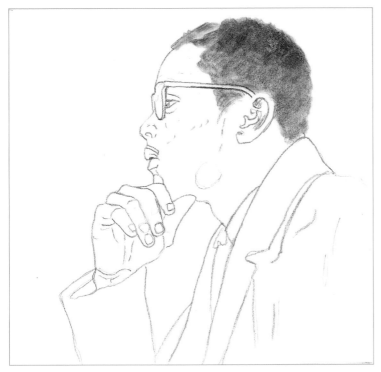

Step 1 To save time, trace this simple line drawing with a light box. Set up a range of values by indicating very dark areas.

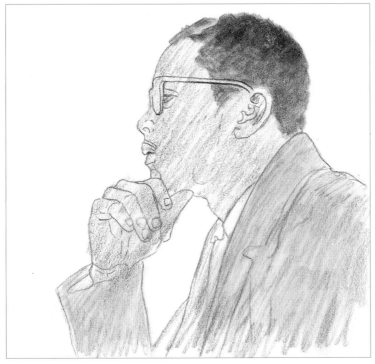

Step 2 Add tone everywhere (except for the shirt collar) with the side of a sharpened charcoal pencil lead. Blend the strokes with a stump.

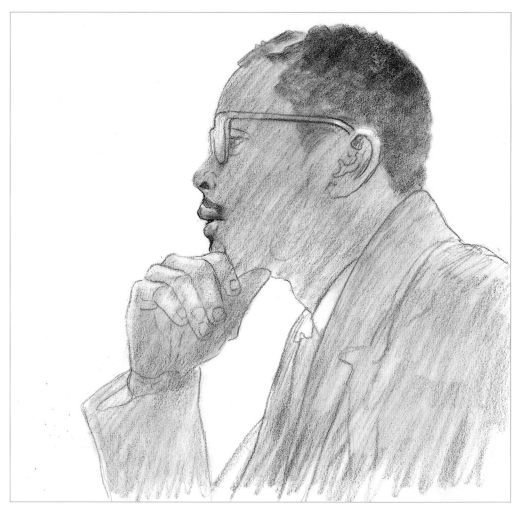

Step 3 In addition to further darkening and blending, begin detailing important likeness areas, such as the mouth and nose.

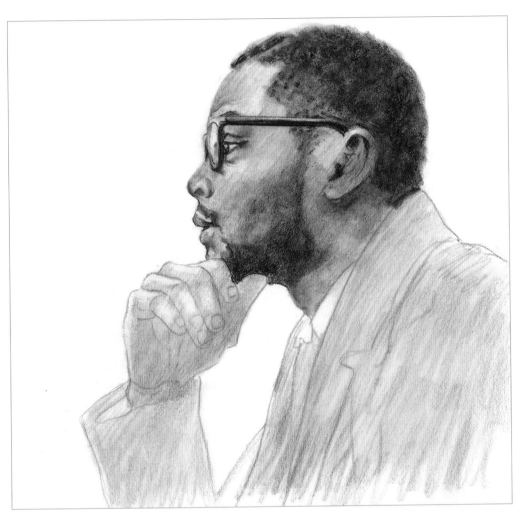

Step 4 To better understand the range of values and details necessary for completion, continue to add dark details, such as the beard, eyeglasses, eye, and hair. For the hair, add dark marks with the point of the charcoal, and then lift around them with the kneaded eraser.

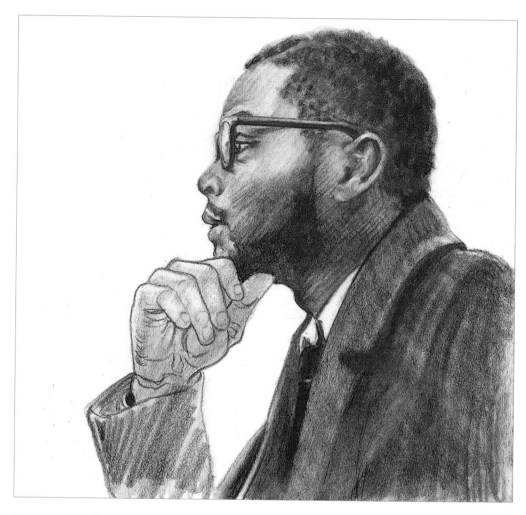

Step 5 Add darks in some areas and lift out from others with the kneaded eraser to modulate the values in the skin. Note the crosshatched marks following the form on the neck and cheeks. At this stage, begin adding some of the hand's anatomical landmarks.

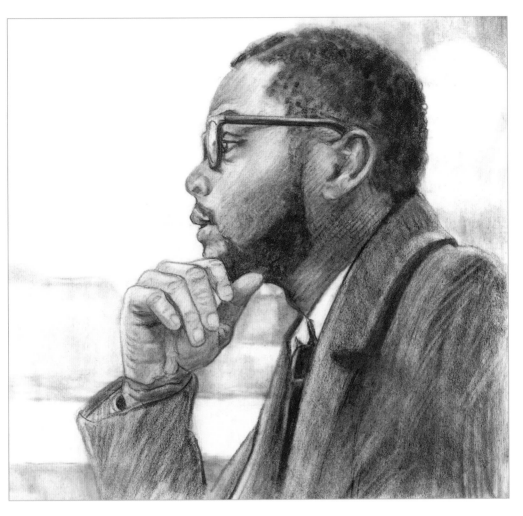

Step 6 Much of the final rendering is done with a kneaded eraser, lightly tamping down the cheek, neck, and hand. Tones added under the fingers make them come forward, which creates depth. Leave the hand understated, as it is not the focal point of this drawing. Random diagonal strokes added to the clothing make this drawing more artistic. How much rendering and when to stop is a personal choice. Keep the background subtle, as not to distract.

Conté charcoal pencil, sanguine, sepia & white Conté pencils, blending stump & two types of erasers on toned paper

Hand Study

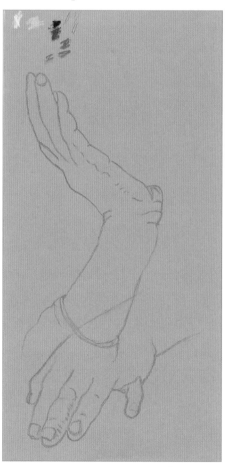

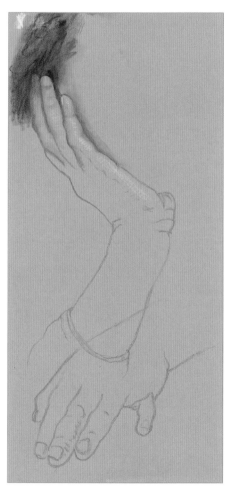

Toned paper is often too thick for a light box, so try drawing this hand study with a sanguine Conté pencil. This study is far more detailed than the actual drawing to show the anatomical details up close.

As you begin to render the fingers, simultaneously add darks to register how these darker values will affect the paper's midtone. When white is placed next to a darker area, it is good to leave some blank toned paper in between as an untouched half-tone.

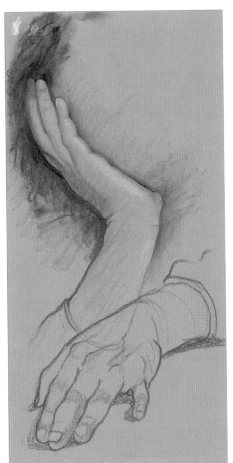

Outline both arms and hands with a Conté sepia pencil. White and sanguine pencils are used to indicate the flesh values.

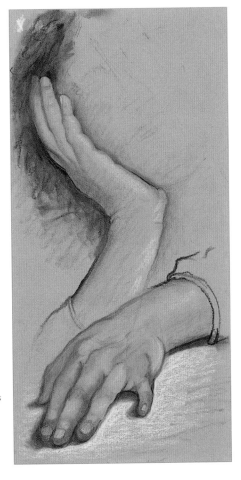

Finally, add cast shadows and surround them with bright white. Making studies like these before diving into an actual drawing is great preparation. Notice how much untouched paper tone shows through the drawing. The warm half-tone paper is a great unifier because it creates a dominant color theme.

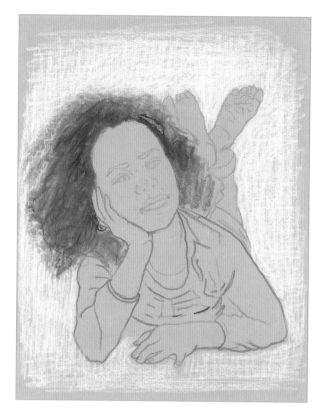

Step 1 Since the paper is already a half-tone, begin this drawing by jumping right into the relationship between the lightest lights and darkest darks. As in the previous demonstrations, this approach creates a value range to work within. Draw the lines with sanguine and sepia; the hair is a mixture of all three Conté colors.

Step 2 As the hair is further darkened, begin to add texture. Add the eyebrows and compare to the light and dark values on the hand.

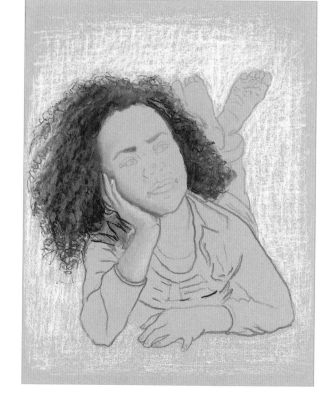

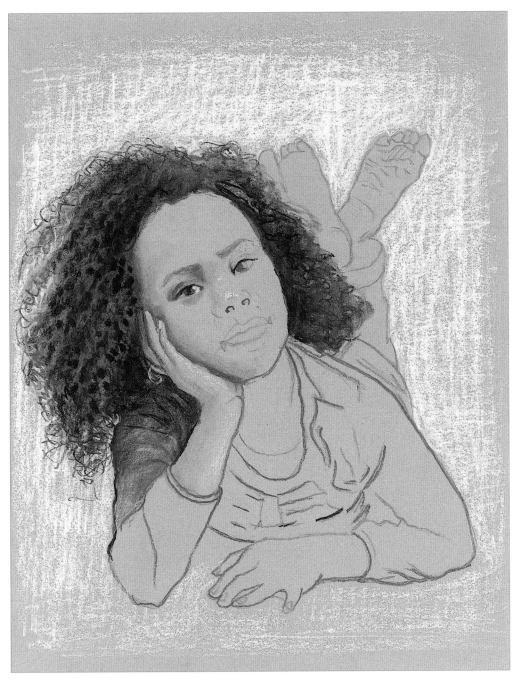

Step 3 The addition of extreme darks between lighter value curls gives further definition to the hair. The eyes and shoulder are important darks, as they indicate which tones to add around and in front of them.

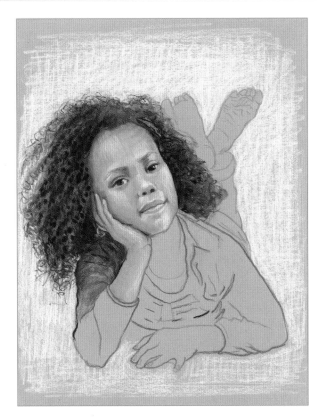

Step 4 Now that both eyes are rendered, their degree of darkness and white determines how much sanguine and white to add to the face. Because the original photo does not show much contrast, remember that front-facing planes receive light and side-facing planes receive tone as a guide. This same rule also applies to the hand and arm.

Step 5 Apply light and shade to the planes of the feet and toes. The dark pants add a nice accent against the hair and body, creating a background (pants), middle ground (body), and foreground (hands and face). These overlapping forms and values create a dynamic perspective. In preparation for rendering the shirt, add cylindrical lines around the arms and body, and three separate tonal areas of black, sepia, and sanguine to the chest and neck.

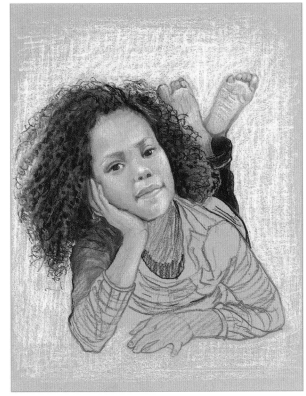

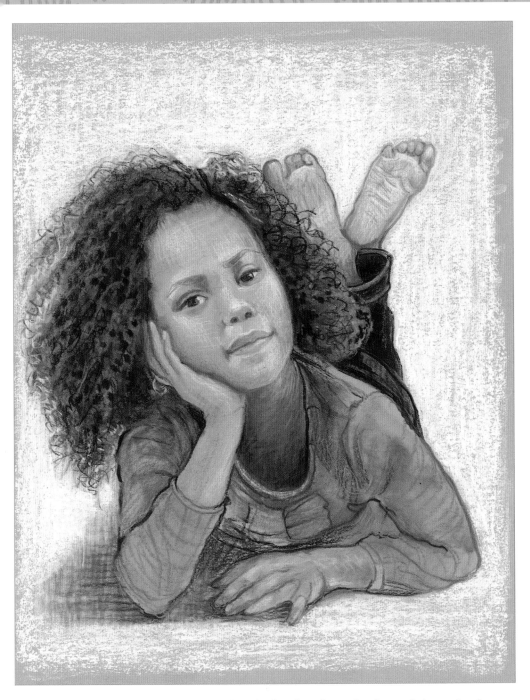

Step 6 Using the blending stump, soften the cylindrical marks on the shirt and sleeves, but keep everything transparent enough for the paper's tone to show through. Blend the three toned areas on the neck and add some crosshatching to the highlights on the face. As a final touch, use a softer white pastel to increase the background's brightness and add dark cast shadows. Although these shadows were not present in the photograph, their inclusion adds more compositional interest.

Step-by-Step Foot Drawings

Both the foot and its skeleton are best understood when they are broken down into their basic geometric forms: the block, the cylinder, and the sphere. The following three demonstrations show how geometric simplification is used to develop drawings from three commonly viewed angles: the top view (dorsal), outside view (lateral), and inside view (medial).

Top View (dorsal)

Compare the skeleton to the final drawing (below), and see if you can recognize the prominent tendons: extensor digitorum longus, extensor hallucis longus, and the tibialis anterior (see page 47). Also look for bony landmarks, such as the first and fifth metatarsal heads and the outer ankle bone (outer malleolus). How many other bones can you recognize, and do you know their names? As a refresher, look back at pages 44-51, "Anatomy of the Foot."

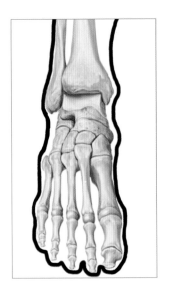 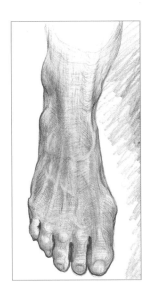

In this simplified version of the foot skeleton, the outer and inner ankle bones (malleoli) rock back and forth over the cylindrical talus bone. The remaining tarsal bones are grouped together as a single asymmetrical blocklike shape. The long metatarsals are semi-rectangular, and the phalanges look mostly cylindrical. This geometric simplification is the easiest way to remember the foot's skeletal shape.

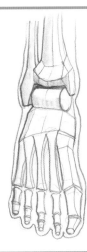

Step 1 Begin this pencil drawing with straight and curved gestural lines to indicate the top and sides of the foot and its connection to the ankle.

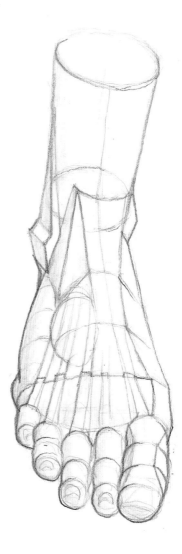

Step 2 Transform the foot's bones and tendons into basic geometric forms, in much the same way as the simplified skeleton, but with form-following cross-contour lines to indicate pencil stroke directions. When analyzing the best way to create a sense of volume from poorly lit photos, thoughtful studies such as these make the task much easier.

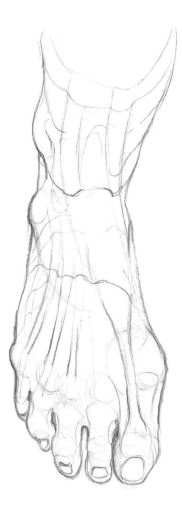

Step 3 Draw the simplified bones and tendons in a much more realistic way to use as a roadmap for the final drawing, which will be more representational and concise.

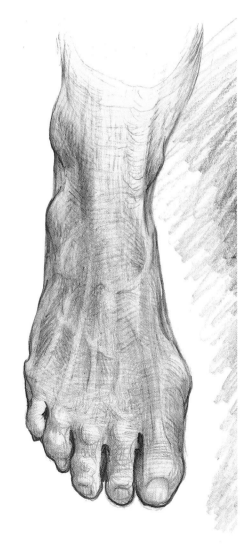

Step 4 Develop the drawing slowly using form-following crosshatched strokes and a blending stump. Use a kneaded eraser throughout to further unify and bring out the veins, tendons, and joints. I'm often asked how much anatomy should be shown in a finished drawing. My answer is that, unless one is deliberately doing an anatomical study, it's better to understate rather than overstate.

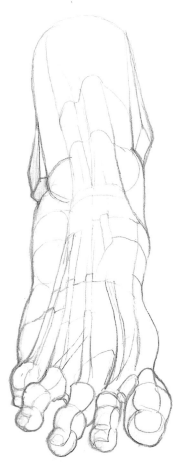

For this pose, the model flexes her extensor tendons, which adds more dynamism to the entire foot.

Step 1 This study offers an opportunity to render toes in a contorted and dynamic way. Cross-contours over the top of the foot and around the lower leg help show how flexed tendons look as they pull on toes. Make the toes themselves into simple shapes (with a definitive top and side), which will help to divide lights and darks when shading.

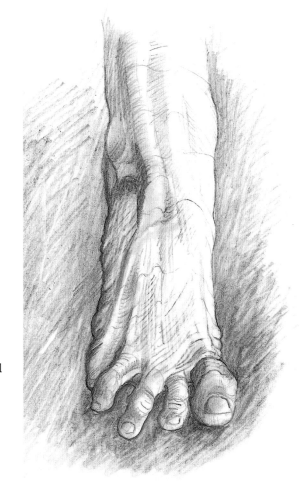

Step 2 The process behind drawing this dynamic foot and the relaxed foot are both the same. In summary, all studies that led up to these two drawings show the importance of taking each photograph through several stages of analysis and simplification. When photographs are copied without in-depth analysis, they often end up looking more like mere photographic copies than artistic, well-thought-out drawings.

Outside View (lateral)

The most prominent muscular landmarks on the outside of the foot are the bulging form of extensor digitorum brevis, parts of extensor digitorum longus, and the abductor digiti minimi. The most visible bony landmarks are the ankle bone (lateral malleolus), the heel bone (calcaneus), and the distal head of the fifth metatarsal (see page 48).

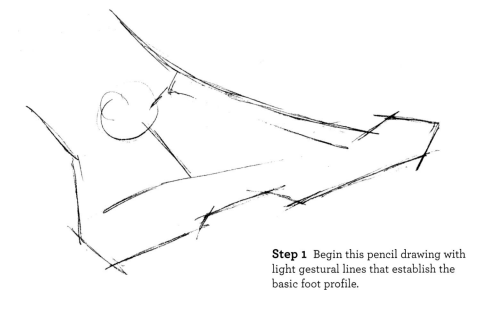

Step 1 Begin this pencil drawing with light gestural lines that establish the basic foot profile.

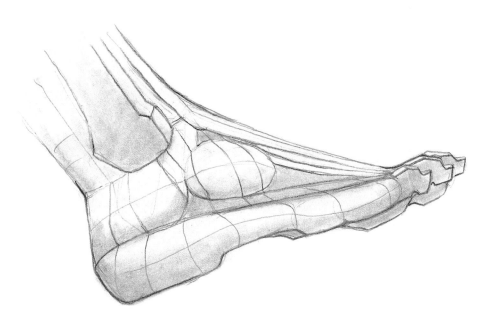

Step 2 Next use cross-contour lines and shading to map out the prominent landmarks. Understanding these forms in such a simplified way will be very helpful when rendering them more realistically.

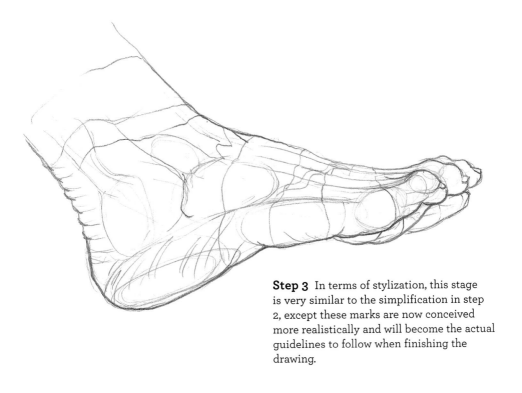

Step 3 In terms of stylization, this stage is very similar to the simplification in step 2, except these marks are now conceived more realistically and will become the actual guidelines to follow when finishing the drawing.

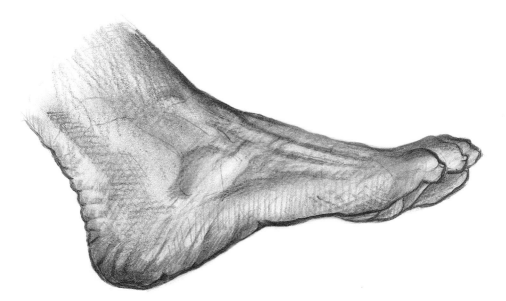

Step 4 Look carefully at this final foot drawing, and then review the pencil techniques described in step 4 on page 102. You will see similarities; both are crosshatched with a sharp pencil and then blended with the stump and kneaded eraser. Notice especially how crosshatching on the outer edge of the foot (abductor digiti minimi) shows volume. After all crosshatching and blending is complete, the heel wrinkles and tendons are lifted out with a kneaded eraser.

Inside View (medial)

The most visible bony landmarks on the inside view are the inner ankle bone (medial malleolus), the navicular bone (above the arch), the heel bone (calcaneus), and the distal head of the first metatarsal (ball of the foot). The most prominent muscular landmarks on the inside of the foot are the Achilles tendon, tibialis anterior, and the extensor hallucis longus (see page 49).

Step 1 Light gestural lines establish the basic foot profile. To avoid getting into details too early, it is best to start with mainly straight lines.

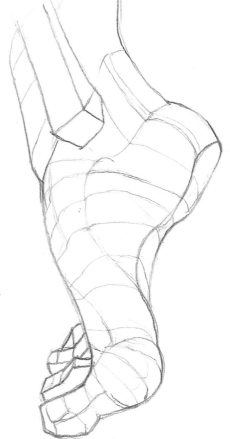

Step 2 When a foot stands on toe, there is a beautiful "S" curve formed from the ball of the foot to the heel bone. As is often the case, the best way to indicate the cylindrical form of this long shape is with form-following cross-contour lines. In contrast to this curve, the ankle bone, Achilles tendon attachment, and heel bone are more square.

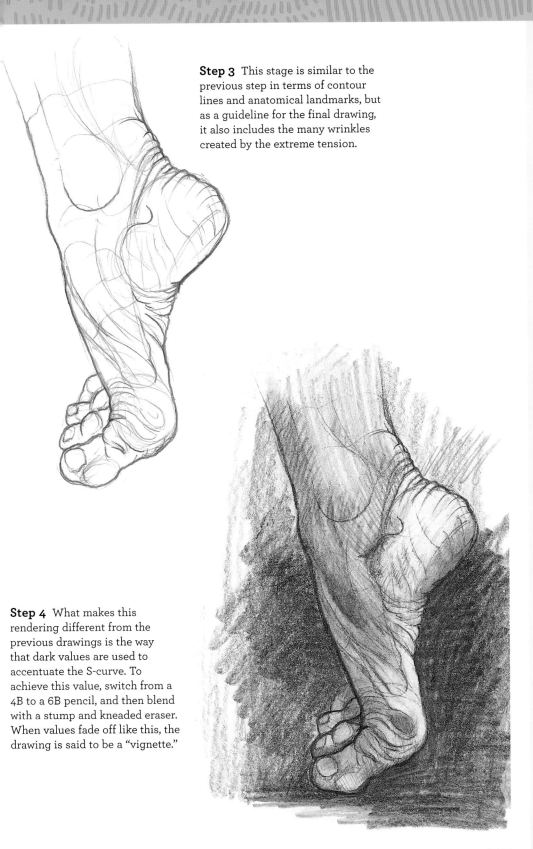

Step 3 This stage is similar to the previous step in terms of contour lines and anatomical landmarks, but as a guideline for the final drawing, it also includes the many wrinkles created by the extreme tension.

Step 4 What makes this rendering different from the previous drawings is the way that dark values are used to accentuate the S-curve. To achieve this value, switch from a 4B to a 6B pencil, and then blend with a stump and kneaded eraser. When values fade off like this, the drawing is said to be a "vignette."

When pressed against the floor, the big toe and baby toe do not show the same degree of flexibility as the middle three.

Step 1 Straight lines are used to define the overall shape of the toes as a group.

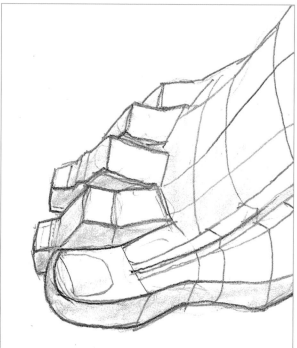

Step 2 The big toe only has two joints; the others all have three. When pressed against the floor, the flexible middle toes are simplified into stairs, with the nail as the last step. The extensor hallucis longus tendon is squarish on top of a curve, which makes it stand out as a landmark (see page 47).

Step 3 Change your conception of the toes from blocks into cylinders and use spheres for the joints. This is now the basis for the final drawing.

Step 4 The most dramatic way to show the difference between the flexible toes and stable instep is with contrast. Create darks in the same manner as the foot on its toes (page 106-107). It is important to always connect the toes to the instep with definite cylindrical shapes.

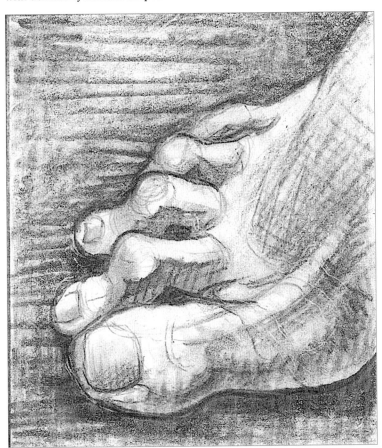

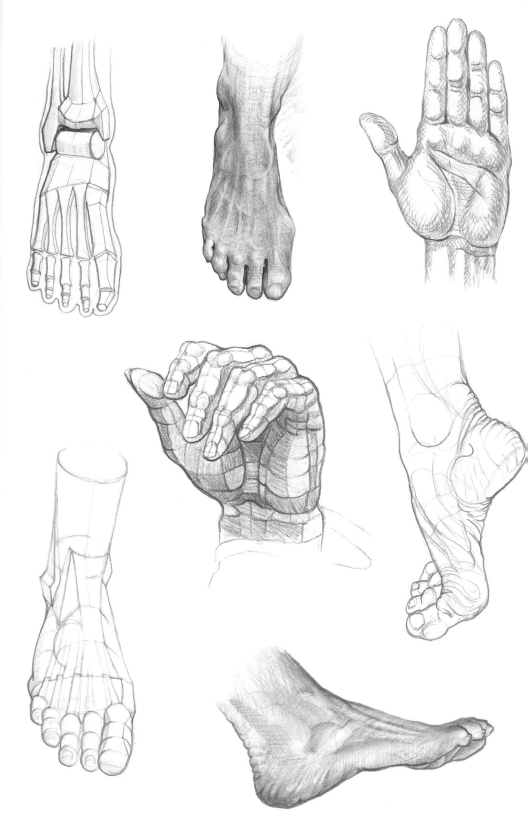

Conclusion

When I first began teaching anatomical figure drawing 40 years ago, much of the contemporary art world looked down on good draftsmanship as an old-fashioned holdover from a bygone era. Art departments in the 1970s and '80s completely neglected traditional training. It was seen as irrelevant in a rapidly changing art world where modernism and conceptual art were considered the only art forms worth pursuing. At the time, teaching figure drawing based on realistic human anatomy was a lonely profession.

But this trend seems to have completely run its course. Once again, good drawing skills are seen as a necessary foundation for artistic training, no matter the style or direction pursued. Based on this renewed interest, traditional art ateliers have sprung up in many parts of the country. If you'd like to enhance your knowledge of hands and feet, I recommend attending an atelier or art workshop near you.

If there are no courses offered in your area, do what artists have done for centuries: Study the works of great masters, such as Andrea Del Sarto, Peter Paul Rubens, John Singer Sargent, or countless others easily found online or in books and museums. Copy their work diligently, learn their shorthand strokes, and see how they solved the same drawing issues you face in your own work. This has always been my own best method of self-education.

The process of drawing can be divided into three stages: (1) absorbing optical sensations (seeing value and shape rather than "things"); (2) analyzing those sensations (knowing what you are actually seeing and finding the best way to depict it); and (3) getting to work (having the courage to begin, using this book as a guide).

Let me remind you to hold on to the large shapes for a long time. It is always tempting to add too many details; simplicity is the strength of a drawing. With each attempt, you will go a little further and learn a little more. And remember that this journey is not about making perfect drawings; it's about making each drawing you create better than the one before it while having a good time.

There are plenty of important ideas in this book, but none of them are useful until they are put into practice. I recommend you get out your pencils and paper, and practice, practice, practice.

About the Artist

Ken Goldman is an internationally known artist, author, teacher, and art juror. A recipient of numerous awards, Goldman has exhibited widely in various group shows and solo exhibitions in The Netherlands, Paris, Italy, Greece, China, Colombia, Mexico, New York, Boston, and Washington, D.C. In California, Goldman has shown at the Oceanside Museum of Art, USC Fisher Museum of Art, and Autry Museum of the American West. Recently (2012–2018), Ken's work has been exhibited throughout China at The Shanghai International Biennale, two Shenzhen International Biennales, and five universities: Jimei, Quanzhou, Tsinghua, Qingdao, and Shanghai.

Goldman's work is included in the permanent collections of the San Diego Museum of Art; Hilbert Museum of California Art; North Carolina's Hickory Museum of Fine Art; Zuo Wen Museum in Qingdao, China; San Diego Natural History Museum; and San Diego Watercolor Society. In 2018, Ken curated an exhibition for the Oceanside Museum of Art titled, "National Watercolor Society: Southern California Inspirations, Past and Present."

The author of fifteen instructional books on pastels, acrylics, charcoal, and artistic anatomy, Goldman has also been featured in several magazines, including *The Art of Watercolour*; *Southwest Art*; *International Artist*; *Watercolor Magic*; *Splash 12*, *13*, and *19*; and *The Artist's Magazine*. Ken is a past president of the National Watercolor Society and is represented by CaliforniaWatercolor.com.

Please visit www.goldmanfineart.com for more information.

Also available from Walter Foster Publishing

978-1-63322-858-0

978-1-63322-697-5

978-1-63322-699-9